it's in the bag

it's in the
bag

what purses reveal—
and conceal

~

Winifred Gallagher

HarperCollins*Publishers*

HarperCollins books may be purchased for educational, business, or sales promotional use. For information, please write: Special Markets Department, HarperCollins Publishers, 10 East 53rd Street, New York, NY 10022.

FIRST EDITION

Designed by Renata Di Biase

Illustrations © Alanna Cavanagh / www.i2iart.com

Library of Congress Cataloging-in-Publication Data is available upon request.

ISBN-10: 0-06-113748-0
ISBN-13: 978-0-06-113748-8

06 07 08 09 10 ID/RRD 10 9 8 7 6 5 4 3 2 1

Contents

Introduction

It's My Bag

~

AT FIRST GLANCE, it may seem odd that just after completing *House Thinking*, a psychological tour of the American home, I decided to write about handbags. While researching our relationship with our domestic spaces, however, I was struck by the under-remarked importance of our emotional ties to certain everyday objects— rocking chairs and teapots, photographs and quilts. Aware of this new interest, my editor asked if I'd like to look into why the purse, epitomized by the luxurious, sought-after designer "It bag," has become a very significant object indeed.

nineteenth-century reticule

Despite an average price of twelve hundred dollars, the market for must-have designer purses is so strong that many high-end department stores are doubling or tripling the size of their handbag areas. Individuals who can't afford an It can rent one by the month from a website called bagborroworsteal.com. Just as many women increasingly consider the right purse to be more important than the latest clothes, many fashion houses increasingly look to purses for big profits that help subsidize costly couture collections. In a stunning example, the so-called Murakami bag, designed by Marc Jacobs in collaboration with Japanese artist Takashi Murakami, earned $300 million for the Louis Vuitton company. Bags from Prada, Chloé, Fendi, Tod's, Chanel, and other topflight brands not only drive the lucrative, fast-growing luxury goods market but also have a huge impact, from design influence to frank knockoffs, on the $6-billion-a-year mainstream purse industry.

From a more personal perspective, I myself had succumbed to that something in the air that increasingly makes having a cool bag seem, well, cool, and plunked down $250 for a caramel-colored leather tote on sale. When I showed it to my husband, he was stunned, and not only by the price tag. "But you already have a purse!" he said. Until recently I had felt more or less the same way. A good black one, a good brown one—you were set for years, if not for life. My own splurge proved that the handbag had become something more, and I wanted to find out what and why.

After doing some research on the meaning of everyday things in general and the purse's sudden prominence in particular, I came up with an analogy that helped me grasp the handbag's new cultural significance: The It bag is to fashion what the iPod is to music. Each object is a beautiful container that marries form and function, a kind of generic art object that its owner personalizes and regards almost as a body part. Like the iPod, the It bag is a small package that delivers a lot of information about its owner and the twenty-first-century metropolitan way of life.

THE FIRST PURSES I recall weren't mine, but belonged to the women of my family in the 1950s. Like their high heels and complicated undergarments, their handbags were emblems of female adulthood. Nana, who enjoyed dramatic "heart spells" well into old age, had a big black purse, stuffed with ominous pharmacy bottles, that fittingly resembled the one our doctor carried on house calls. My mother had various bags—brown for everyday, black for dressed-up, colored for special occasions—that all shared a quality I thought of as "radioactive." Like a medieval chatelaine's "pocket," which held money and keys to the household's larder and treasure, my mother's purse was an important article filled with important things that children were not to touch. She is ninety-two now and infirm, but her bag never leaves her side; even though it

was a gift from me perhaps twenty-five years ago, I am still not comfortable opening it.

My three aunts' handbags were as distinctive as their personalities. Stylish Peggy, the wife of the family's millionaire, had a gorgeous black alligator facsimile of Grace Kelly's eponymous Hermès. High-spirited Eleanor, who had been a flapper and a hosiery model, favored colored bags that matched the spike heels she wore even around the house. An early single "career gal," Mary had well-made purses in black, brown, navy, and bone that complemented her tailored suits. Befitting the straitlaced Eisenhower era, most of these ancestral purses were structured "frame" handbags that snapped shut with a no-nonsense click.

Perhaps some little girls are fond of purses, but I was indifferent to the diminutive black patent boxes that came at Easter along with new Mary Janes. Only during high school in the early sixties did the bag begin to take on both practical and symbolic importance. For the first time, I had to carry keys and wallet, comb and hankie. In my milieu "collegiate" girls carried reddish brown, rather matronly handbags made by Etienne Aigner that matched their penny loafers. "Hoody" girls preferred big black plastic bags in more flamboyant styles that complemented their pointy-toed shoes. Just as I took the occasional

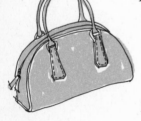

Prada bowling bag

joyride in a hoody boy's hot car before "going steady" with a college boy who drove an Austin-Healy, I experimented with a dramatic black purse or two before succumbing to stiff mahogany leather.

In the later sixties, like the culture in general, bags loosened up. The tailored brown Bonnie Cashin clone I took to college gave way to a bright green suede fringed hippie bag picked up while backpacking in Spain. In the seventies I carried thrift-shop purses from the thirties and forties or imported ruglike bags smelling faintly of livestock. In the career-oriented eighties, I bought a nice Coach bag, whose rugged leather and clean lines bespoke the company's role as a military supplier.

Toward the end of the eighties, the purse and its meaning, epitomized by Prada's iconoclastic black nylon backpack, suddenly changed. A young woman in jeans, T-shirt, and jacket carrying one of the proliferation of new It bags made the lady in a couture ensemble look Mumsy. Although I was far more preoccupied with my newborn twins than with fashion, even I pushed the double stroller down to the Gap and bought its no-frills variation on the ubiquitous backpack purse.

~

AS MY PERSONAL experience suggests, a purse is not necessarily just a purse. The new discipline of material culture regards such objects as clues to how an era's big ideas play out in real life. Thus a handbag—Gap or Gucci, vintage croc or

canvas tote—and its contents—Prozac and sunglasses, Black-Berry and security ID—offer insight into a person and her society. This more nuanced way of looking at us and our stuff is increasingly represented in the media, from the *New York Times*'s "Consumed" column to "shopping" magazines such as *Lucky* and *Domino*.

It's in the Bag is not a shopper's guide but an invitation to consider one seemingly simple everyday object's complex meanings to people who design, make, market, assess, and use it. The book begins with the purse's history, which reveals how women gradually appropriated what had been a male accessory and turned it into an artifact that both practically and symbolically reflected their expanding lives and roles in the larger world. Next we'll look at the world of high-profile designers, who strive to combine talent, perfect timing, recognizable trademarks, personal charisma, and celebrity endorsements in the creation of a must-have brand and its It bags.

Far from the chic world of luxury accessories, we'll examine the hardscrabble life of young designers, who first must master the venerable leather goods craft, then parlay their creative vision and hard work into producing their own bags—and possibly companies. Then we'll visit powerful tastemakers, such as fashion editors, who shape our sensibility and even preselect the bags from which we choose; because many of these women can have any purse they want, often for free, the ones they choose speak almost as eloquently as their critiques.

From the purse owner's very different perspective, we'll consider the bag's psychological meanings, one of which was first famously remarked by Sigmund Freud. In *The Interpretation of Dreams*, he declared that the purse—in his era, a roomy Victorian-style satchel—was a symbol of woman, and that putting something inside it represented sexual intercourse. Be that as it may, many women value the purse not only for its utility but also as an expression of identity, a declaration of status, a link to the past, or even as a reward or consolation for something missing from their lives.

Finally, some very different women express a range of attitudes about handbags, from an army major's antipathy to a fashionista's enthusiasm to a collector's obsession. Their testimonies suggest that certain objects aren't just stuff we have, but, as William James, the father of American psychology, declared, silent partners in our daily experience—and sometimes even part of who we are. He regarded the self as the "sum total of all that a man can call his"—not just his body and mind, but also "his clothes, his house, his wife and children, ancestors and friends, his reputation and works, his lands and yacht and bank account. All these things give him the same emotions . . . not necessarily in the same degree for each thing, but in much the same way for all."

Based on their feelings about their stylish leather homes away from home, many women agree.

it's in the bag

ONE

Handbag History

From Pouch to Prada

~

MIDWAY BETWEEN THE ritzy uptown Manhattan stores of Hermès and Fendi and the boho downtown meccas of Prada, Marc Jacobs, and such small shops as Rafé and Jamin Puech, lies the Museum at the Fashion Institute of Technology (FIT), a treasure trove of riches that bring the modern purse's history to life. When not on display, the fifteen hundred handbags in its collection rest in a special climate- and light-controlled storage zone several floors above the exhibition space.

It's hard to believe that FIT's vintage bags, much less the Chloé Edith, Fendi B, and Marc Jacobs Stam, are descended from a simple drawstring pouch of the sort found with the frozen body of a Neolithic man discovered in 1991 in an alpine glacier near the Italian-Austrian border. By the medieval era, men carried money and keys in a more elaborate bag suspended from their belts, which attracted thieves who accordingly became known as "cutpurses." In the seventeenth

century, men's clothes were equipped with sewn-in pockets, a development that dealt the "man bag" a blow from which it has never really recovered.

Strange as it seems, for most of history women didn't have purses. In the medieval era they wore "pockets," or pouches that tied around the waist, which were later, depending on fashion, sometimes replaced by the sewn-in sort. It was only in the late eighteenth and early nineteenth centuries, when the slim, revealing Empire look ruled out bulky pockets, that chic women took up the new reticule, which resembled our dainty modern evening bag. As women's status and independence slowly increased, so did their need for a handbag. By the Victorian era, when ladies began to travel more, manufacturers obliged them with mass-produced, metal-framed bags whose large, satchel-like shapes and locks look oddly contemporary today.

The true "age of handbags," however, began in the early-twentieth century when, whether for work or pleasure, women moved about much more freely and needed to carry not just wallets and keys but also makeup. By the 1920s the ubiquity of the lipstick and mirrored compact helped to make the purse an important fashion accessory.

In a special section of the FIT museum's cloistered storage area, Clare Sauro, the curator of the accessories collection, dons white cotton gloves before hunting for treasures that illustrate the purse's post–1920s development. Moving through aisles of steel shelves filled with boxes labeled "Hermès" and

the like, she says that until relatively recently in Europe, most great purses—even on the runway—weren't produced by fashion houses but by French and Italian leather goods firms known for their fine saddlery, such as Hermès and Gucci, or luggage, such as Prada and Louis Vuitton. These venerable companies successfully translated their expertise with luxurious but practical leather goods into elegant, durable, classic handbags.

For much of the twentieth century in America, which lacks Europe's long tradition of producing fine leather goods, most women carried purses created by anonymous designers—some highly skilled—employed by handbag manufacturers. Laying an elegant black clutch from the 1930s on a cushioned, specially lighted table, Sauro notices what looks like dust on her protective gloves. "Oh! She's crocking," says the curator. "When suede decomposes, it starts to come off." Putting the bag aside for conservation, Sauro says that she particularly treasures such elegant American purses, because in this practical nation, "the idea of the bag as an exquisite jewel mostly isn't there."

Like much of America's clothing, its handbags have long tended toward the casual and functional. Sauro points to a transitional moment in the 1940s, when smaller, more refined bags like the chic little clutch gave way to large, sturdy ones—a change that reflected women's more active "Rosie the Riveter"–inspired lives during World War II. When the soldiers and sailors came home to court and marry, clothes

and accessories, such as the fanciful straw figural and Lucite box purses of the fifties, briefly became feminine and dainty again.

In the same decade, however, the sporty strain of American bags was evolving in the practical but stylish direction epitomized by the great designer Bonnie Cashin. Her purses for Coach, several of which are in FIT's collection, might have been designed yesterday. Indeed, Cashin's user-friendly, streamlined styling, good leather, and handsome hardware live on in the bags and totes made not only by Coach, but also Kate Spade, Donna Karan, and other American designers today.

Across the Atlantic, the 1950s ushered in two iconic purses that preceded today's numerous It bags. Holding up a gorgeous brown crocodile Kelly, Sauro points out that this Hermès classic was inspired by a saddlebag. (Similarly, Louis Vuitton's pouchy Noé shoulder bag was modeled on a wine carrier; FIT's bright red Hermès bucket purse, embellished only with "Swiss cheese" perforations, might be an elegant thoroughbred's nose bag.) Underscoring the utilitarian inspiration behind some of Europe's most luxurious purses, Sauro picks up a Chanel 2.55—named for its February 1955 birth date—and points out that the purse's signature quilting de-

Patchwork bag
by Louis Vuitton

4

rived from the jackets worn by racetrack stable boys. Even its celebrated gold strap was made from the same utilitarian chain Chanel used to weigh down her classic jacket's hem. The forward-looking career woman also hung her 2.55 from the shoulder, presciently freeing other women to follow her example and grab life with both hands. In the 1980s Karl Lagerfeld took over Chanel and has since produced seemingly endless variations on Coco's purse, which remains a gold mine for the fashion house.

In the 1960s fashion, like the rest of Western culture, questioned traditional rules. Gently jiggling one of the era's Paco Rabanne purses, made of linked metal disks, Sauro says, "The structured bag almost disappeared. Fashion was casual, and there were lots of fabric and ethnic bags." Toward the end of the 1970s, again reflecting a cultural shift, the purse assumed more form, epitomized by the period's crisp little disco bags.

By the 1980s the enormous social changes that began in the sixties had profoundly changed most women's lives. Like men, they too now often had jobs, unmarried sex, and workout regimens. As in the past, the increase in female roles expanded the purse's importance and functions. Women were no longer carrying just a lipstick and a wallet but also office files and trainers; their bags were not just fashion statements or perks from rich husbands but often manifestations of their own successful careers. Even the august Hermès created a bag for the globe-trotting model-actress Jane Birkin, who com-

plained that she couldn't fit all her reading material into the hard-to-open Kelly.

The cultural changes that had transformed women's lives were embodied by Prada's revolutionary 1988 backpack purse. Till then high-priced luxury bags created by famous designers or venerable European leather goods firms had mostly been carried by a small circle of so-called jet-setters: Princess Grace, with her eponymous Hermès; Jackie Kennedy, who favored Gucci; and Coco Chanel's customers, who snapped up her quilted, chain-strapped 2.55. By the late eighties, spurred by the iconoclastic Miuccia Prada, the designer purse suddenly exploded its old boundaries—not only of style, but also of wealth and class.

One needn't be a fashionista to think of several reasons why Prada's first It bag was quickly followed by Fendi's Baguette, Tom Ford's horn-handled Mombasa for Yves Saint Laurent, Kate Spade's nylon tote, and the many must-have designer purses since. First, in our age of global trade and sophisticated mass production, there are simply more and better bags to buy. (The dark side of having many choices is that what was once a fairly simple decision—black or brown, day or evening—can now demand considerable time and energy, and even provoke anxiety.)

Just as there are more purses, there are also more people willing and able to buy expensive ones. Prolonged general prosperity since the 1980s has greatly expanded not just the ranks of the very rich but also the upper- and middle-middle

classes, who are much likelier than their forebears to spend hundreds of dollars on a good purse or thousands on a luxury model.

The handbag's apotheosis also reflects the fashion industry's strenuous efforts to glorify not only the purse but the purse of *this minute*. Prada's early success proved that, compared to couture clothes, bags, which are much simpler to make, sell, and ship, are a much easier way to make lots of money. Accordingly, major designers added or expanded their purse collections and spent lavishly on marketing, so that stylish magazines now sizzle with costly full-page ads and spreads promoting the latest bags.

Corporate fashion's decision to push the purse du jour was amplified by the increasingly sophisticated Internet. Its almost instantaneous electronic transmission of images from Paris runways or Hollywood's red carpets means that anyone with access to a PC or TV, much less *People* magazine, can see the exact bag that Carine Roitfeld or Mary-Kate Olsen is carrying this week. As a result a new legion of affluent consumers whose degree of sophistication was once limited to readers of *Women's Wear Daily* has drastically accelerated the fashion cycle, so that in some circles, even the previous season's purse can seem out-of-date.

The trendier, more eclectic fashion scene has also increased the bag's impact by undermining the old-fashioned coordinated outfit. No longer concerned with carefully matched clothes or accessories—red purse with red shoes, black with

black, and so forth—women feel freer to splurge on an expensive bag, perhaps in seafoam green, that can work with either jeans or dresses. "Women once wanted a head-to-toe look of gloves, hat, shoes, and bag that all went together," says Sauro. "That's too much bother for us now—plus it says you've thought way too much about clothes. Now the goal is to look like you've just thrown yourself together and don't really care."

She may favor the horn-rimmed glasses, un-made-up face, and Belgian shoes of an Ivy League professor, but Dr. Valerie Steele, the director of the Museum at FIT, is also wearing a black taffeta Isabel Toledo dress, ruby hoops, and a red Balenciaga bag. Her ensemble befits a priestess of the postmodern brainy-glam look pioneered by Miuccia Prada. After earning her PhD in cultural history at Yale, Steele helped to establish the history of fashion as a scholarly field; indeed, FIT is part of the State University of New York system. With a liveliness unusual in academics, she expands on the history of the It bag.

Along with more choices, money, marketing, and trends, Steele connects the bag craze to clothing that's increasingly uniform, even unisex. In a casual era dominated by jeans and jackets, whether the Gap's or Helmut Lang's, a purse often makes a stronger statement than its owner's subdued, anonymous-looking separates. Accordingly, bags increasingly come in colors—teal is a "new black"—and with lots of details. As Steele says, "Many women have become fashion

crows who wear black all the time! Bags and shoes are two of the few ways we can still play with dressing."

The popularity of luxury bags is also partly a response to a plumper population in general and the huge, aging baby boom generation in particular. Of all fashionable items, accessories, which require no disillusioning trips to the fitting room, are the most forgiving. Regardless of her size, shape, or wrinkle quotient, a woman can wear the most stylish shoes and bag she can afford.

(Distinguishing between the emotions of shoe and bag enthusiasts, Steele says, "It's affairs versus marriage. Shoe people say things like, 'I don't care how much they cost, I just fell in love with them.' They have a harem. Bag people sound more like serial monogamists—'I love this purse now, and we'll see about next year.'" Eventually, she says, bags will out: "At a certain point in life, comfort means more. You say, 'Five hundred dollars, and I'll never wear those heels.' You're never too old for a beautiful pair of shoes or a bag, but you may become too sensible for the shoes.")

From her historian's perspective, Steele says that although the majority of women worked in the nineteenth century, the modern career woman's complicated practical and emotional needs have greatly increased the bag's significance. On the most obvious level, women need an attractive carrier of the stuff—paperwork, cells, iPods, baby toys—they need to get through a demanding eighteen-hour day. "Women feel that a bag is a survival kit, a security blanket," says Steele. "They

say things like, 'I can't be more than ten feet away from my bag.' Or, 'I could live for a month in the subway with what I have in my bag.'"

A case in point, Joanna Coles, the editor of *Marie-Claire*, wife, mother, and glamorous member of New York's British literary mafia, says that she uses her big Pollini leather tote "rather as Mary Poppins used her carpetbag. It's a bottomless pit filled with remedies to the various emergencies I anticipate befalling me during the day." One of the worst things that can happen in a busy woman's life is wasted time. Thus, says Coles, her tote is a kind of mobile office that holds bills and "personal admin" data filed in an old address book "in case I have a spare five minutes." Should she wish for a more pleasurable experience on her subway commute, she reaches into the bag for a *New Yorker* or *British Week*: "It doesn't matter if they're old, they must only be unread." If her lunch date doesn't arrive on time, she extracts a book from the capacious Pollini: "Heavenly!"

To allow Coles to capitalize on potential quality time with her two boys, her tote holds a plastic bag of toy cars, mini-chess game, crayons, and notebooks: "I fear being stuck somewhere with my children with nothing to do." Finally vanity must be served, usually in the form of cool sunglasses, several plastic barrettes, and perhaps four lipsticks. As if it were a metaphor for a working woman's life, Coles says, "My bag is chaotic, but I know that everything is in there somewhere!"

From a historical perspective, the luxury bag's high profile reflects the profound change in women's status and income. As a man might exhibit his prosperity with a Cartier watch or a BMW, Jo Coles proclaims hers with a pricey Pollini. "A lot of what women say about bags comes down to 'status signifiers,'" says Steele. "Bags help them suss out who's their kind of person and who's not. A black cashmere turtleneck can be any brand, but the bag is 'Oh! Marc Jacobs.' You can wear jeans and cowboy boots, but as long as you carry a two-thousand-dollar bag, people will place you where you want to be placed." Conversely, at least in certain milieus, "There's nothing sadder than last year's It bag," she says. "You get on a waiting list and pay so much for it, then a year later, it's just an 'old bag.' What a derogatory term!"

Regarding the silent language of the twenty-first-century handbag, Sauro says, "Right now I'm carrying a Kate Spade, whose designs say 'classic.' A Coach says 'conservative.' The Balenciaga motorcycle bag says 'boho, hip, cool.' A Chloé Paddington, 'Hardcore fashion, up on the latest.'"

If a handbag's exterior communicates a woman's status and chic, its interior holds the secrets and clues to her private identity. "If you want to understand a woman, look in her bag," says Steele. "One carries aspirin and Valium, and another enough makeup for an army. You can really tell what she expects from life."

Summarizing the handbag's recent history, Steele declares it to be "a female fetish object that's not about sex,

particularly—high-heeled shoes are about sexuality—but about identity and security. If the male fetish is the phallus object, for women it's an identity object. Your bag is a stand-in for you."

Perhaps the best testimony to the handbag's new status in America's fashion capital lies south of FIT in Chinatown. In what looks like a typical novelties store, the front room is hung with frank but un-logoed plastic copies of It bags of the sort sold by street vendors all over town. However, cognoscenti discretely ask the Chinese proprietor if they can see the "bags in the back." With a nod, he dispatches a Mexican clerk to open a door in what turns out to be the shop's fake back wall. Inside a windowless space, there are rows of fakes, some sort of fabulous, some not.

Unlike the cheaper knockoffs in front, the backroom bags are tagged with illegal logos of Hermès, Gucci, Coach, and other designers. Many of the plastic purses are in the sixty-dollar range, while leather ones are closer to a hundred dollars. At six hundred dollars, or a tenth of the price of the originals, the faux Birkins and Kellys are the most expensive, yet they must fail to fool a discerning eye. The best approximations of the real thing are the leather-trimmed canvas "Coaches." On the other hand, spending a hundred dollars for a fake when you can perhaps get the real thing for about three hundred dollars is not necessarily a good investment.

Watching his customers closely, the clerk supplies prices and works the door. He admits two middle-aged ladies with

strong southern accents, who giggle naughtily, as if they're entering a drug den. After a certain amount of time, the clerk asks if the women have finished looking. As they slip out, an Asian woman who's leading a small group of white women slips in, suggesting a new wrinkle in New York City tourism. One thing is clear: At the high and low end of the market, the It bag has nudged out shoes, jeans, and jewelry as the must-have fashion item.

Grace with a '50s Kelly

TWO

The Designers

Making "It"

~

Clutching a BlackBerry in one hand and a leopard-skin Rafé purse with big-buckled black patent handles in the other, Roopal Patel, senior fashion director for women's ready-to-wear and accessories at Bergdorf Goodman, begins a whirlwind tour of one of the best purse collections under any one roof in America. In a fitted black brocade coat over a white wool retro dress, black opaque stockings, and four-inch heels, Patel is a consummate New York It girl with a fashion professional's perspective on the It bag and its creators. "A purse is the quickest way to register fashion changes and trends and to update your look," she says. "You love a bag on sight or not. And instead of committing to a designer's whole clothing collection, you can get the feeling by just buying the bag."

Three minutes in Bergdorf's make plain that there are any number of beautiful purses made by talented accessories

designers. Therefore, the few that become It bags must offer more than good looks. Fashion experts have clear ideas—some that overlap, some that differ—about the special ingredients that turn a purse into an obsession.

From Patel's perspective, must-have bags, no matter how different looking, share two features. Such purses always have a distinctive feature or two—a shape, a handle, an "embellishment," or ornament—that makes it instantly identifiable. The Hermès Birkin's intricate closure and the Goyard tote's distinctive chevron pattern are good examples of these design signposts, which immediately flag the eye of prospective buyers and admiring cognoscenti.

Each It bag is also stamped with the charisma of a high-profile maker, such as Hermès, or designer, such as Miuccia Prada, and that of the chic "girls" (fashionese for "women") who carry it. (Like Prada, many famous designers are thought to be "creative directors" who guide and edit employees' designs.) In buying a Prada or Hermès purse, the new owner benefits from the so-called positive contamination of its glamorous provenance.

To illustrate her It bag formula, Patel puts the recently reissued version of Chanel's classic 2.55 bag on a counter beside the company's chunky Rue Cambon, produced much later by Karl Lagerfeld. Each purse is infused with the glamour of the legendary French fashion house and its two celebrity designers. Moreover, says Patel, although the bags look quite different, they share two features that make them im-

mediately recognizable: "They're all about what Chanel does best—the quilting and the logo."

If many fashionable older women want Chanel—as Patel puts it, "You get to the age of thirty, and you have to have one"—their daughters want Marc Jacobs. The first American whose bags have international cachet, he is one of two younger designers whom Patel singles out for their It bags. Regarding the requisite instant-recognition factor, she says that although Jacobs is "a true pioneer, always a season or two ahead," his purses follow a design formula that immediately marks them as his: a classic, often vintagey shape that's given a quirky twist. Picking up a twelve-hundred-dollar Stam in a luscious taupe leather, she says that Jacobs created it by taking a distinctive old-fashioned knitting-bag silhouette, then updating it with Chanel-style quilted leather and a chunky gold chain. In coming seasons, Patel says, "Marc will keep taking the Stam idea forward with new tweaks."

Where Patel's second It criterion is concerned—the designer's stardom and glamorous clientele—no one can match Jacobs. His celebrity was established with his 1992 "grunge" collection, when his artfully disheveled models in Nirvana-style plaid shirts, shrunken sweaters, and orthopedic-looking shoes instantly rendered perfect grooming and "matchy-matchy" clothes as dead as Coco Chanel. Jacobs's branding, as a company's public image is called, is inextricably tied to his complex persona. He's fashion's wildly successful king of cool, yet he comes across more like a sensitive, misunder-

stood young artist. ("Marc is very, well, complicated," says one magazine editor. "If you tell him you love his new bags, he'll say, 'Really? You do? I don't know . . .'") Along with his talent and prescience regarding what clever, attractive young people will want next, Jacobs's edgy image imbues his bags with an ineffable hipness that his customers seek by association.

Perhaps the best testimony to Jacobs's status in the accessories world is that he designs must-have bags for two different companies. In 1997, the big international luxury products firm LVMH (Louis Vuitton Moët Hennessy) lured him to Paris to reinvigorate Louis Vuitton, and in return agreed to back the designer's own New York–based Marc Jacobs line. As was said of the magical collaboration of Fred Astaire and Ginger Rogers, Vuitton gave Jacobs class and he gave the company sex appeal. In one celebrated bag, Jacobs reacted against the prevailing logomania by boldy replacing Vuitton's traditional LV with a funky graffiti version done by the late artist/punk-chic designer Stephen Sprouse.

If the designer's sleek LV purses evoke Europe's club-hopping *jeunesse dorée*, his quirky, vintage-resonant Marc Jacobs bags, such as the Stam and the Sofia, suit his American muses from the arts and entertainment worlds. Like Jacobs himself, these boho *jolies laides*, including Sofia Coppola, Chloë Sevigny, Rachel Feinstein, and Kim Gordon, seem far more interested in film, art, and music than fashion. Perhaps the best testament to the power of his brand and his savvy, upscale It girls is the speed with which his bags are instantly

knocked off for street vendors and more subtly ripped off by corporate competitors.

Proceeding to her second consummate It designer, Patel loops the straps of a Chloé Paddington, this one in silver python, over her arm. "We've been reordering this bag since fall 2005," she says, "but we just can't keep it in stock." The purse's instant-ID feature is the same padlock embellishment that brands a whole group of bags, including the earlier Silverado, so that they instantly say "Chloé." Regarding the designer's requisite charisma, the hip young Englishwoman Phoebe Philo first worked with her friend Stella McCartney at Chloé, succeeding her in 2001 at the age of twenty-seven; in early 2006, she resigned to be with her new baby. Like Jacobs at Louis Vuitton, Philo at Chloé was what Patel calls "a blast of fresh air in an old design house."

Pausing briefly before a boxy, strappy motorcycle-reminiscent bag made by the British label Mulberry, Patel says, "The Roxy was photographed being carried by Kate Moss and boom! Wait-list squared!"

The important supporting role that celebrities play in the genesis of an It bag is amplified at the Fendi counter. Pointing to the Spy, Patel says that photographs of Beyoncé, Jennifer Lopez, and Jessica Simpson

Paddington by Chloé

carrying the slouchy bag with its distinctive braided leather, vaguely Egyptian closure embellishment produced "a feeding frenzy, even at two thousand dollars." According to Patel's formula, the combination of the Fendi cachet and its new B bag's immediately recognizable buckle-like embellishments, curvy shape, and chain handles augurs for It status. "The B bags might not even make it to the floor," she says, "because they'll all be wait-listed."

IF GREAT STYLE, identifiable branding, and a high-profile designer and fans are three elements in the making of an It bag, Silvia Fendi, who first made headlines in the early 1990s with her trim little Baguette, adds another: "You must do the right bag at the right time. You can try, try, try, you can make the most beautiful bag, but if it's not for that moment . . . A certain alchemy is required."

To foster the alchemy that produces the right bag for the moment, Fendi says, "I mostly just try to follow my instincts and make things I'd like to have and wear myself. I try to avoid looking too much at what other designers are doing, and I never listen to marketing people!" Instead Fendi indulges her propensity for risk-taking: "I like to do things that are different, to face a challenge every season. People say, 'What will the new Fendi bag look like?' They know they'll be surprised."

Her It bag criterion of timely innovation explains why

Fendi followed the pouchy Spy with the structured new B. When she saw the waistline becoming important in fashion again, she seized the moment, she says, "to mold the B in the shape of a woman. I also wanted to do the opposite of what I did six months before, so I worked with a constructed bag that has a lot of leather details."

As a modern career woman herself, the forty-something Fendi has some personal views on the purse's increased importance. Sheer convenience plays a role, she says: "Working women's lives are very, very fast paced. Sometimes we leave home in the morning and don't come back till the next day. It's easier for a busy woman to bring, say, an evening purse to the office and change her look with a different bag than with different clothes."

B by Fendi

In the designers Anna Fendi, her mother, and Carla Fendi, her aunt, Silvia Fendi had powerful early models of busy working women right in her own family. As a child she didn't consciously think of following their career path, but looking back, she says, "I realize that I always found reasons to visit the studio. At the time, I thought I just wanted to see my mother, but now I think that I wanted to see what she and Carla were doing." When she eventually decided on a fashion career, young Silvia worked her way up at Fendi, starting

with making copies and answering phones. Growing up in the big, creative brood has served her well since 1999, when the house formed a partnership with LVMH. "I'm used to working with other people," she says. "The new managers become part of my new family. And now, people don't just think I'm here because I'm Anna Fendi's daughter. I feel more professional."

Fendi thinks that, along with meeting the needs of busy women, the bag's heightened significance reflects its new importance as "a very personal statement. After all, it's a box that holds all your secrets. Both inside and outside, it reveals your personality." Just as she invests her designs with her own individuality, Fendi encourages her customers to express theirs by offering them numerous versions of a popular design. She attributes much of the Baguette's runaway success to its many combinations of colors and materials. Similarly, the original patent leather B is now available in forty variations, including embroidered straw, lace, and other materials as well as traditional leathers. "To look at one idea from different points of view!" says Fendi. "That's my signature."

Based on her hands-on experience as a designer, Fendi advises women buying a new purse to look for good quality "because you use your bag every day," then follow their hearts: "If you choose well, you'll have an It bag for a few seasons that will become a classic."

≈

GREAT STYLE, INSTANT identification, celebrity designer and fans, perfectly timed innovation—the creations of Miuccia Prada, arguably the first and still foremost designer of contemporary It bags, have all those attributes and something more. Prada's secret ingredient is her way of infusing a traditional luxury item with an iconoclastic postmodern sensibility so vividly that the handbag almost seems more like an agent than a reflection of cultural change.

Traveling back and forth through time, Prada visits, say, the 1950s, retrieves its bowling, gym, and doctor's bags, then transforms these dusty thrift shop relics into cutting-edge fashion. To adapt a vintage design to twenty-first-century taste, she reinterprets it in different sizes, colors, and materials, perhaps replacing plastic with leather and canvas with python. Alligator and crocodile bags—long the most expensive and luxurious accessories—were traditionally a safe black or brown, but Prada decided to do them in pink and red; if she does brown, it will be nude, not the usual chocolate.

Recently Prada's distinctly oversize bags, stamped with her family firm's original logo, suggest that she has revisited the bygone era of luxe luggage—after all, that was the company's first business. But hers are not her grandfather's suitcases. Her runways sparkled with hot pink crocodile wheelies and big gold carriers. Some new handbags resembled a Victorian lady's traveling satchel, and others a grandmother's purse made two or three times bigger.

Prada's flair for combining the traditional and the revo-

lutionary pervades her personal as well as professional life. She's the heir to a luxury goods company but also a former member of the Communist Party. In her youth she studied both mime and political science. She's an international mogul and an Italian wife and mother who shuns the press and glitzy social events. Deciding that both the old bombshell and modern feminist roles were too limiting for postmodern women, she created her signature "sexy librarian" look—a mix of prim and seductive, nerdy and cool, conservative and cutting edge—that instantly changed the way many hip women dress. In short, Prada is the poster girl for the kind of complex woman for whom she designs.

To historian Valerie Steele, Prada's old-fashioned insistence that fashion is not about honing and pushing a certain look, but about change, has revolutionized the accessories field: "By doing something completely different each season that's really striking and exciting and highly collectible, Miuccia has fed the mania for shoes and handbags." In a rare interview, while discussing the excitement occasioned by her little black backpack, Prada referred to her penchant for the new and different: "I think the point was that these were fashion bags for the first time. Labels like Gucci and Hermès had always done the same bags for many years. I treated bags as if they were fashion. Also, this was something practical, but also very luxurious."

Dependent on the consumer's hunger for the next big thing, the lucrative It bag phenomenon requires a constant

supply of new designs that render last season's dated. While many designers still churned out fancy embellished purses in 2006, Prada took off in the opposite, more conservative direction. Her simpler, luggage-inspired bags made even a return to tradition into an innovation. In the fashion world, she told her interviewer, "once you've got something, you're already thinking about what's next. Maybe it's a little hysterical. Now every day I'm thinking about change, it's a constant anxiety and probably a reflection of society's anxiety in general. The big deal about fashion is really very recent, this hysterical pursuit of newness. It may be a good thing, or a bad thing, but it's really defining this moment."

Just as she's always ahead of the design curve, Prada was among the first to sense the bag's new meaning and importance in both women's lives and the fashion industry. As she explained to British *Vogue*, "I was born into accessories, and everybody said we would never be successful with clothes because we started that way. Now it has reversed, and you cannot be a fashion designer unless you do shoes and bags. I think dressing is a very complicated process if you are interested in fashion and you want to express yourself through it. A bag or a pair of shoes is a good way to identify yourself stylistically without having to be stressed with the entire outfit."

~

NOT ALL MAKERS of esteemed purses are particularly concerned with designing It bags the likes of which have never

been seen before. As America's oldest and biggest accessories firm, Coach has its own recipe for a great bag: high quality, fair price—between $325 and $375 on average—and what Reed Krakoff, the company's president and creative director, calls "timely but not trendy style."

Since 1941 Coach has produced iconic American bags, such as totes and hoboes, but "nobody wants something exactly the way it was thirty years ago," says Krakoff. "That's the trick—to make the traditional right for today." Ten years ago, after stints at Ralph Lauren and Tommy Hilfiger, he joined the venerable, $500 million-per-year firm to do just that. When he started, loyal customers "went to Coach when they needed to replace the handbag that wore out," he says. Now, however, the purse's increased importance means that women buy multiple bags "because they have to have them. That has been my real challenge—to make Coach part of the handbag's fashion cycle."

Like Marc Jacobs at Louis Vuitton, Krakoff must bring a well-known company forward—a task that carries risks as well as benefits. The first step, he says, is "to figure out the essence of what made you successful. With Coach that meant quality, understated American good taste, and functionality—after all, we made bags for military women and airline stewardesses."

Next Krakoff had to decide how to give this reliable brand some pizzazz. "How do you make all of the good things about Coach relevant to a new world? A new market?" he

asks. "It took a while to figure that out, and then to figure out what that insight looks like in a handbag." One result is the popular Hamptons tote collection, which updates the familiar, functional L.L.Bean–style canvas version with different, unexpected materials, more interior compartments, and a lighter, sleeker look. "We've done that bag with alligator trim and canvas trim," says Krakoff, "and expensive or inexpensive, it always looks good and like only Coach could have done it. It takes a long time to come up with something that's iconic in that way. That bag just works."

That this successful line of bags is called Hamptons, after Long Island's fabled Gold Coast, is no accident. Many timely designs are based on a narrative concept called a "fashion theme." For example, Krakoff has been working on a men's "trade" collection that was inspired by thinking about what an imaginary architect, interior designer, and photographer would want in a bag. Rather than simply reproduce the resulting archetypes, says Krakoff, "we make a new bag that keeps the attitude—perhaps conveyed in the pocketing—and the functionality, which is the heart of American design. Our customers want something sexy and fun that also works. That's Coach's overarching theme."

The inspirations for his design themes don't usually come from the current fashion scene, says Krakoff, but from the worlds of art, architecture, and films: "I'll watch a movie that's set in sixties New York and see a suede bucket bag. Or an actress will make me wonder, 'What's that girl going

to carry?'" Recently watching the classic Ivy League weeper *Love Story*, he was struck by a simple split-suede bag with a big buckle—"one of those kind of crude bags from back in the sixties," he says. "I get a lot of inspiration from images like that. A bag, a girl, an attitude—then I try to cater to that idea and make it timely."

Considering that *Love Story* starred Ali MacGraw, a sixties It girl, as a free-spirited Radcliffe student, it's not surprising when Krakoff says, "That's the flavor of next year—a slightly bohemian hippie chic." If that same theme flavors the purses of other designers, he doesn't particularly care. "We don't really think about It bags," he says. One reason is Coach's huge, disparate consumer base—more than two hundred stores in the United States and more than four hundred worldwide—which requires many collections and hundreds of bags per year. "It would be tough to sit down and think of a single bag that everyone wanted," says Krakoff. "Plus, I don't want us to become known for one thing." That said, a single must-have Coach bag can mean $40 million in sales. To come up with a wildly popular purse that both pleases loyal customers, who associate the company with practical good taste, nice leather, and heavy brass hardware, while adding enough sex appeal to attract new ones, who are interested in fresh colors and textures, involves a lot of work—and trial and error.

Perfecting Coach's updated, timely-not-trendy brand "is a holistic process that has to do not just with bag design, but advertising, store environments, and the corporate cul-

ture," says Krakoff. "All those things have to change, which takes time." Rather than rely on outside agencies to present its product, the company does all of its own art direction, graphic design, ad placement, and the like. Even cool bags and hot ad campaigns are not enough, however. "If we don't also renovate the stores, people would walk in and say, 'Gosh! This place looks the same as before. . . .'" Similarly, as Coach makes its previously rather rugged shops prettier and more feminine, the bags must be reevaluated in light of their new setting. As Krakoff says, branding is "a very organic process in which each area gives birth to ideas for others. There are many, many decisions."

One of an accessories company's most important decisions is pricing. The most expensive Coach purses are eight hundred dollars, but most average less than half that amount—three times less than the typical It bag. The ratio of quality to price is complicated, says Krakoff, "because an alligator bag, say, *does* cost more to make than a leather or canvas one." However, he says, unknown to the public, many fancy European brands now manufacture offshore, which is cheaper, and some of their high-priced bags are, after all, mostly fabric or plastic. "There's no reason such a product should be fourteen hundred dollars," he says. "To me, unless you're talking about a Birkin, there's no difference between the average It bag and a Coach."

Looking ahead, Coach has high hopes for the new Brooklyn hobo, which is a chunky sixties-inflected bag with a belt-

ing leather handle and a soft, drapey body. "It's the kind of bag that can mean different things to different people, from 'I can throw all my stuff in it' to 'This is slinky and sexy,'" says Krakoff. "We don't come up with one that crosses over from the practical girl to the fashion girl every year. That's hard to do."

~

As the perspectives of some top designers suggest, there are different recipes for creating must-have bags, but they often have certain ingredients in common: great style, instantly recognizable features, a celebrated creator and customers, perfect timing, novelty, and consummate branding.

Far from the luxe environs of Bergdorf's and the posh stores of famous designers, the young artisans who aspire to take their places work at mastering the venerable craft of making bags. Some even dream of starting their own companies.

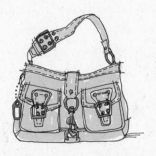

Brooklyn Hobo by Coach

Jackie with a '70s Gucci

THREE

Bag Business

From Craft to Company

~

MOST SHOPPERS WHO admire the sleek handbags enshrined in swanky shops are unaware of a far less celebrated but essential realm of the accessories world, where young designers learn to make basic types of purses. Many go on to work in the industry, and a few eventually go into business for themselves. One of their staunchest mentors is Ellen Goldstein-Lynch, the founder and chairperson of FIT's accessories design department, which is the only such program in the United States. The Sigerson Morrison team, who have their own chic company, learned their trade here, and other graduates work at Coach, Judith Leiber, Cole-Haan, and Kenneth Cole.

Wearing floppy pants and a pink striped hoodie, Goldstein-Lynch invites a visitor into her snug office, which is decked with a gift-shop array of cheery tchotchkes. Considering her role at this cutting-edge fashion school, her comfy style is

nothing short of iconoclastic. "It works for me," she says, "and the students' first response to my office is 'Oh! It's so homey and cozy!' Many of them are far away from home, and we kind of become their family."

Like a proud parent, Goldstein-Lynch shows off her fashion-forward students' bags—some with matching shoes—which are showcased in hallway vitrines. Pointing to a pleated cadmium yellow leather clutch embellished with a matching leather rose, she says that such an "envelope" bag is a relatively simple assignment that students complete in their first semester.

At the opposite end of the sophistication spectrum is an eye-popping trapezoidal black-and-yellow checkered leather purse with a chain strap. This bag is a senior's hands-on "thesis," which is meant to reflect everything he or she has learned. For one such comprehensive project, a young woman made a VW bug bag that, thanks to clever electronics, actually moved. Another duplicated a Miró painting, in that each element in the picture became a pocket or other feature that could be used in the purse. To Goldstein-Lynch, such inventiveness exemplifies FIT's effort "to get the students thinking outside the box."

Creative vision is important, but young designers must also master bag making's practical side. Students in the two-year accessories program, which mostly enrolls recent high school graduates who aim to work in the fashion industry, take up to five handbag courses. The one-year program draws

a more eclectic group, says Goldstein-Lynch: "We've had everybody, and I mean *everybody*," including PhD's, MDs, teachers, and a chiropractor who wished to advise his patients on ergonomically correct purses. However, most one-year students just want to learn how to make soft, relatively easy bags for themselves and their friends or perhaps to sell at crafts fairs. Recalling the White House intern-turned-tote-designer, she says, "Monica Lewinsky's enterprise is a perfect example of the handbag cottage industry."

Goldstein-Lynch herself came to purse design by a circuitous route. Her first career was teaching the speech and hearing handicapped, but she was also an accomplished weaver and tapestry maker. When she exhibited some of her work at a prestigious crafts show, she was hired by a company that made knitting bags. Goldstein-Lynch learned her trade on the job, then developed a lucrative new line for the firm. After recruiting her to write a grant application for a new accessories program, FIT asked her to stay on and run it.

An escalator ride above Goldstein-Lynch's office, a bright classroom hums with sewing machines and student chatter. One young man shows off his nearly finished black-and-white-checked satchel with brown leather trim and handles; another student slides her lower arm through the two buckled straps that replace conventional handles on her black envelope bag. One wall is covered with famous designers' names in beautiful calligraphy, but otherwise the space intentionally duplicates the students' future industrial workplaces. Here

they learn how to make basic types of bags, including the envelope clutch, box, tote, bucket, messenger, drawstring, minaudière, and highly structured frame, whose difficult construction Goldstein-Lynch calls "an art."

The first step in making a purse is to sketch the design, then translate it into a pattern. To discover any flaws, students then often do a mock-up version in inexpensive muslin. Next, they cut their leather or, increasingly, some other material. ("We push them to think in terms of sustainability," says Goldstein-Lynch. "We have no American tanneries anymore, which means we have to import leather, which requires fuel and money.") Finally the students do the gluing and sewing—the hardest part, which requires operating different sewing machines. A bag's collar and bottom, for example, are stitched "in the air" on the cylinder machine, rather than on the usual flat surface. By graduation, says Goldstein-Lynch, "not everyone will be a pattern maker or start his or her own company, but they will all *understand* the business."

Back in her outrageously cheery office, Goldstein-Lynch declares that the American accessories industry, which has traditionally been better at copying than creating, is now more design-focused and competitive with European companies. She admits Prada's influence on the American market, but she doesn't find Italy's much celebrated purses to be "exceptional per se." Any country whose workers pay attention to detail, construction, and craftsmanship will produce a good bag for the money, she says, offering the mainstream brands

of Dooney & Bourke, Cole-Haan, and Adrienne Vittadini as American examples. Goldstein-Lynch herself carries a messenger bag—"That's me, all the time"—but she appreciates the must-have purse phenomenon's tonic effect on the industry that employs her students. "Just five years ago, even many chic women only bought two bags a year," she says, "and now they're buying six or eight!"

Octagon by
Judith Leiber

~

THAT'S GOOD NEWS for young entrepreneurs like Helen Mariën, who learned the handbag trade at FIT and is now the chief designer, manager, and salesperson for her eponymous shop in Manhattan's trendy Nolita neighborhood. The rigorous process of making her dream come true illustrates the combination of talent, confidence, hard work, and grit that being an independent accessories designer requires.

According to Mariën, a petite, mid–thirtyish Korean American with a ready laugh, the first requirement for an aspiring designer is to invest his or her bags with an inimitable "nuance," or sensibility; she describes hers as "modern unique." People often ask if her purses are designed by an architect, she says, "because they're elegant and simple, yet without trying too hard, different."

The bags displayed on Mariën's walls are tailored takes

on classic shapes that she enlivens with interesting materials, such as snakeskin and wool, and details, such as inventive stitching and contrasting piped seams. One example is Some Like It Suede: a simple, crisply styled envelope that's made of dark brown lambskin trimmed with tweed and unexpectedly carried by two bamboo hoops.

In America's fashion capital, where lots of cool indie bag boutiques compete for discriminating customers, Mariën made a smart business decision. As a small sign says, her purses are "baked daily" on the premises and can be ordered à la carte; custom orders account for about 70 percent of her sales. A woman who buys the Slouch Pouch, a simple rectangular shoulder bag that's Mariën's year-round bestseller, can choose from three sizes and many colors and kinds of leather and Ultrasuede, to say nothing of different types of stitching, strap lengths, hardware, and linings. It bags notwithstanding, trend spotters predict a growing market for fashion and accessories that have this kind of personal, handmade, unique feel.

In a tidy white workshop beneath the store, amid bolts of colorful fabric and shelves of hardware, buttons, and beads, Alfonso Beltran, Mariën's craftsman-in-chief, executes her customized designs bag by bag, spending between eight and twenty hours on each. Seated at her desk across from his workbench, she traces her clean, less-is-more aesthetic back to her Asian background. "If my mother sees something in a department store that seems overdone, she says, 'That has

ghosts flying behind it,' which is the Korean expression for 'too much extra stuff.' I always think to myself, 'Can I take something away that will make this bag better?'"

Picking up a personal favorite called Love Me or Leaf Me, Mariën points out the distinctive leaf-vein motif stitched on the bag's sides, the Bonnie Cashin–style turn lock, and the python trim that complements the brown Ultrasuede body. She loves the lightness and durability of the top grade of this modern synthetic fabric, which costs as much as (and is indistinguishable from) real suede, yet is nearly indestructible and easily cleaned. In cheaper mass-produced purses, Mariën says, the lining is often bunched up and wrinkled, but Leaf Me's sleek red Ultrasuede interior is just as well made as its outside—"like two bags!"

Such attention to detail attracts Mariën's typical customer: a picky professional woman who's over thirty-five, knows what she likes, and doesn't necessarily identify with brands. To add a little spark to their well-designed, expensive but low-key clothes, they want a purse that's "a bit different," she says. "People often ask them where they got their bags, and that's what they like—some attention, without looking like fashion victims."

Like her customers, Mariën

Some Like It Suede
by Helen Mariën

sees a purse as a way to be stylish without being trendy. Her fascination with bags dates to a poignant childhood experience in Iowa, where her immigrant physician father, aided by his wife, worked hard to establish a medical practice. Time spent with her mother was limited, says Mariën, "but one of my big memories is of her sitting down with me and saying, 'Let's fix your handbag.' She put in some gum, a change purse with some coins, a comb. I was only six or seven, but she was treating me like an adult. I got her attention—and this thing I could carry around with me." Her enthusiasm increased in adolescence, when her very small stature made clothes shopping a nightmare. "Handbags were my thing," she says. "For me, a great bag is still one that I'd wear myself."

Some unlikely adventures intervened between the little Iowa girl fingering a purse at her mother's knee and the poised designer in her own Manhattan shop. In college Mariën studied filmmaking, then worked as a personal trainer—one reason why she closely attends to a bag's ergonomics. Approaching thirty, she faced the fact that she had always secretly wanted to work in fashion. After some initial sewing lessons and art classes, she studied accessories sketching and handbag design at FIT. For the first time, she says, "I felt, 'This field is where I belong.'"

Once she learned her new trade, Mariën decided that the usual route of producing purses in a factory and selling them through department stores would limit her control over quality and price. Convinced that her handbags were different—

"that I have a niche"—she boldly opened her Mott Street shop on November 11, 2001, when downtown Manhattan was still reeling from the World Trade Center attacks. She worked nearly nonstop, and eventually Mariën and her husband went their separate ways. "Being in the fashion business was tough, and it still is," she says. "You do it because you love it."

Although she found selling very difficult at first—"I practically used to hide from the customers"—Mariën now enjoys it. From shoppers' comments, she has also gleaned important design tips, such as the wide appeal of adjustable straps, convenient cell phone pockets, and secure zippered closures, and that women with back problems love purses that can be made into backpacks.

Regarding It bags, Mariën maintains that a purse produced in a factory just can't compare with one that's handmade by a fine craftsman for a specific individual. She picks up a vintage brown alligator bag, which she has just "renovated" for a customer by replacing the worn strap with a hiplooking chartreuse ribbon handle. "The beauty of what we do is in the little things," she says. "It sounds like a cliché, but what makes our bags special is that they're made with love."

~

HER HEARTFELT CONVICTION that a handbag should not only look good, but also make a woman *feel* good helped propel Kate Spade from designing and marketing bags in

her apartment's living room to running her own major accessories firm. Her purses and totes are beautifully designed, of course, but what mostly sets them apart from other fine

bags is a certain euphoric air. Whether they choose the tailored red leather Chesterfield Baylor purse or the casual yet paillette-studded paisley Golden Gate tote trimmed in bright yellow boarskin, Spade's customers get a little sip of psychological champagne from the Ivy League cocktail parties of the 1950s and 1960s, wittily reimagined.

Chesterfield Baylor by Kate Spade

Pervaded by Spade's distinctive fun-loving, neo-retro sensibility, her Manhattan corporate headquarters feels like a piano bar frequented by the descendents of Franny and Zooey. The bright bags and often sparkly shoes evoke MG convertibles and frozen daiquiris, Lilly Pulitzer shifts and white ducks—Jack and Jackie—but with a postmodern wink, even a giggle. "I grew up with traditional," says fortyish Spade, "but my idea is, 'Don't make it *too* serious.' I'm going for more of link to preppy than the literal thing. Something that makes you feel nostalgic about a terrific period."

Over the yips of her little woolly dog, Spade says that for her, a great bag is "one that makes me go, 'I have to have it!'" With her simply delighted laugh, she exclaims, "It's really just

that! It's about a woman's sensibility, not price, which is why the same person might own a Hermès bag and an L.L.Bean tote. My own sensibility is playful chic."

Because she sticks with elegant, simple shapes, Spade can express her playful streak in a bag's bright color or unexpected point of interest—a dusting of glitter on a daytime tote, perhaps, or a sporty bone handle on an evening envelope. Stroking a little clutch, she says that its clean form allowed her to indulge in the fuchsia satin that would be too much in a trickier bag: "A simple background allows me more flexibility."

Spade's path to the pinnacle of American accessories took her from Kansas City, Missouri, where she was born and raised, to college in Arizona, and finally to New York, where she became the accessories editor at *Mademoiselle* magazine. Outside Manhattan, American women wear color. At Condé Nast, says Spade, "everyone wore a lot of black! That's when I started feeling more confident about how I wanted to look. I didn't toss the black dress or boots, but I didn't feel it was necessary to dress in a black uniform, either."

Looking at fashion from both an out-of-towner's and an editor's perspective pushed Spade to envision stylish, functional handbags enlivened by color and pattern—practical but not boring. If *Mademoiselle* was doing a story that focused on pink, she says, "I'd wonder, 'Where's the pink bag or loafer I want?' I saw what was out there, and what wasn't."

In 1993 Kate and Andy Spade, her husband and business

partner, wanted to shake up their lives with a career change, so Kate decided to fill that hole in the marketplace with her first bag. "I never thought I'd be a designer," she says, "but Andy said, 'Handbags? How hard can it be?'" Following her first It bag—the iconic square nylon shopper—the influential Council of Fashion Designers of America gave Spade accessories awards in 1996 and '98, and her business took off; in addition to bags and shoes, the company now produces stationery and home furnishings.

Over her years in the business, Spade has watched women become, like her, more expressive where accessories are concerned. "There was a time when you thought, 'I don't need a bag, I already have a bag.' Now you think, 'I want something to carry at that cocktail party.' Or, 'I want something that makes me feel good. I don't know that I need it, but I *like* it.'" Regarding It bags, Spade says that although there's "something kind of fun and exciting about them, when a bag is no longer It, then it's Not It. You end up chasing your tail. And now that the purse is such a big deal, a woman almost *becomes* the It bag she carries!"

Of her own designs Spade's current favorite is the big, bright pink straw Malta Cabana tote trimmed in white leather. "I use 'summery' things all year round," she says, with her fluty laugh. "I'd take this on a plane in the middle of winter. I adore it!"

Suddenly the very idea of *not* carrying a beach bag in February seems dreary.

~

OUR IDEAS ABOUT the must-have purse are shaped by talented designers and their works, from classic totes to the latest It bags. However, our notions of style—and our purchases—are also influenced by the decisions that a small, highly influential group of tastemakers formulate many months before the goods hit the stores.

Tastemakers

Deciding What's "It"

~

D ESPITE THE BENIGN illusion that we choose our own ac-
cessories, our choices are subtly, or not so subtly, influenced
by powerful fashion arbiters. They include buyers for stores
from Bergdorf's to Target, who determine what purses we'll
peruse, and editors who tell us
which ones are In and which
are as Out as last year's It
bag.

Of these journalists,
none is more authorita-
tive than Candy Pratts
Price. Formerly the ac-
cessories director at *Vogue*
and now executive fashion
director of Condé Nast's
Style.com, she so embodies

Jane with an '80s Birkin

the Broadway/Hollywood version of the high-octane New York fashion editor that one instinctively looks for the little dog tethered to her desk leg (she indeed favors terriers).

True to type, Pratts Price never speaks when it's possible to exclaim. Pondering her own bag collection, including a one-of-a-kind black patent Kelly ("Danielle Steele wanted Hermès to make one for her, but they wouldn't do it!"), she decides that the white Birkin is her favorite: "It was a whole production! I paid for it! I picked the leather! All the hardware in silver! The monogram on the bottom! People just were, 'That is so *fabulous*!'" Somehow it's not surprising to learn that her favorite Milan restaurant supplies a little stool to hold her Birkin, or that when Pratts Price met Queen Elizabeth, Her Majesty too was carrying a white handbag: "Why does she even have a bag? She never freshens up—she can't, she's *the queen*! I was insane to know what was in it!"

Attracted by her exuberant, fast-breaking reporting and photos from runways and red carpets, Pratts Price's two million Internet readers—"I went modern!"—make her a force in the fashion world, from design to media to commerce ("After all, we're trying to sell clothes!"). She clicks on her spring accessories report, and the screen fills with a big, bright paisley-and-leather tote by Bottega Veneta, then a similar shape by Donna Karan. "You see the sensibility!" she says. Her readers will, because Pratts Price has gone to all the spring shows, looked at hundreds of bags, and zeroed in on these big, fresh-looking totes as among the season's best.

As a tastemaker Pratts Price helps anoint It designers as well as bags. Clicking on a small, ladylike purse, she says, "And here's Marc, going for that old Gucci silhouette." Like many fashion insiders, she talks more about this person than

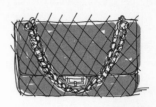

2.55 by Chanel

his product, which gives insight into the dynamics of Jacobs's success. "Marc is truly cool and truly sincere about what he does, so his work just pours out of him," she says. "He's cool Marc! You feel it. That's it!" Certainly hip, well-heeled young women such as Sofia Coppola—every designer's dream demographic—agree. Remarking on the "cheap form of advertising" in which designers give bags to much-photographed celebrities, Pratts Price says, "Those pictures start a fever, but when *you* get that bag, it's not the same as the one Marc gave to Sofia. She got the alligator one!"

A fashion editor must not only know the designers and bags du jour, such as those on Pratts Price's glowing screen, but also command a historical perspective on accessories. Despite the recent fuss, she says, the bag is not new: "We had alligator bags in the fifties! The Delman years! Fall bags for fall shoes! Beach bags!" Like other observers, she links the purse's new prominence to the decline of carefully coordinated ensembles and women's more active lives: "With the exception of Vera Wang—you never see a bag on her, she has a car and

driver, what does she have to carry?—very few of us live like [fifties supermodel] Suzy Parker, with one long leg emerging from a limousine!"

Any fashionista can tell you that the It bag appeared in the late eighties, but Pratts Price has the backstory that links this fashion development to the long spending spree of the economic boom's new rich: "It was Wall Street! It was excess, it was more and more! It was *big gold chains*! It was very much 'Let's get a big watch. A pink alligator bag!'" Recalling the excitement generated by a Prada quilted nylon tote with Chanel-esque chains, she says, "suddenly, companies were competing over accessories, and we had branding like we had never seen before. Now that LV or CC logo really mattered!"

A fashion editor must be able to spot a trend that's barely more than a glimmer in a designer's eye, but her job has a practical, consumer-oriented dimension as well. Of the ubiquitous hobo, Pratts Price says, "it ruins your manicure, you can't find your keys, and it's not a pretty silhouette—like a hump on your hip!" By her lights a good bag is as much about function as form: "The woman is freer now, she moves, she's on the go! But she needs to carry so many things! Some girls have a blow-dryer in their bags!"

Along with providing enough space and compartments for a woman's stuff, a well-designed purse must contain it securely. "I'm not talking about Lindsay Lohan, but most women want a bag that completely closes," says Pratts Price.

"If it doesn't, the designer is risking a shy sale." The bag must also be comfortable: "A woman has to like how it looks and feels in her hand or over her shoulder when she's opening the car door, holding the kid." Then too, says Pratts Price, "you have to scale your bag to what you're going to be wearing. If you have a bulky winter coat, you can't carry some little square thing on a chain!"

Her own bag today—a Chanel 2.55, supplemented with a small Vuitton duffle for her camera and electronics—illustrates Pratts Price's ideal of form and function. "Chanel!" she exclaims. "Chanel cared about practical things!" She points out her purse's back pocket for theater ticket or coat check, the places for pen and gloves, the ratio of lightness to capacity, and the inspired chain that works as either a handle or shoulder strap: "And all so beautifully done!"

When Candy Pratts Price predicts a change in fashion in general and bags in particular, it's newsworthy. "Clothes are going be more classic, more cleaned up," she says, clicking on the spring 2006 Chanel couture collection. "Look at this! Totally clean, lovely pieces. You'll love this—maybe with the skirt a little longer. You open your closet, that dress is there, you put it on, you're done! All you need is good grooming. You can't wear these clothes without grooming!" Regarding the right purse for the simpler, more classic fashion of the future, she says, "My feeling is 'smaller and neater.'"

Like Pratts Price herself, her advice for women in search of the perfect purse is a heady mix of the practical and ex-

travagant. Expressing the latter, she says, "If you get it in alligator, it will be good forever. That's the key! No matter what else you're wearing, if you have that alligator bag, they let you in at the Four Seasons!"

~

LIKE OTHER NEWS, fashion coverage is increasingly delivered on Internet sites such as Style.com and on cable TV, but a few elite magazines remain bibles. Mostly unconstrained by pedestrian considerations such as practicality and cost, their editors can feature, say, the thirteen-thousand-dollar pink crocodile Prada wheelie if they choose, and they often do. Few of their readers could or would pay that much for a bag, but many of the expensive, cutting-edge styles first seen on their glossy pages influence popular taste and are eventually modified for the larger market.

Vogue's minimalist-chic reception area, populated by a very tall, thin, frankly rather wan-looking East European model who's nearly dwarfed by her Chloé hobo, is a picture of calm serenity. Just inside the glass doors, however, despite racks of gorgeous frocks and big shopping bags filled with designer purses, the rush-rush atmosphere of high seriousness evokes thoughts of the Pentagon. From a small windowless office amid her department's hive of desks, buzzing phones, luxurious samples, and young assistants and their It bags, Filipa Fino, the magazine's accessories editor, can make a call and summon any purse in the world.

Because she's a fashion arbiter, Fino's own bag is worth noting: currently Alexander McQueen's big brown leather Novak, which is already nearly impossible for ordinary consumers to get. Like the Kelly and the Birkin, the Novak was inspired by an actress—in this case Kim Novak, one of the sexy, buttoned-up blondes whom Alfred Hitchcock dressed in perfectly tailored clothes and matching accessories. Channeling Novak, McQueen updated a Hitchcock lady's handbag with the new oversized, elongated "directional" shape, which Fino also likes because "it holds all my stuff, including a camera."

Some tastemakers are born as well as made. Since the vivacious Fino's youth in her native Portugal, where she pored over fashion magazines with her chic mother and grandmother, clothes and accessories have been her passion. She learned the editor's trade during the wild excesses of the eighties and its supermodels ("I'd get to go on shoots with Kate and Naomi to places like Cuba"). After starting as an editorial assistant at *Harper's Bazaar*, Fino moved up the masthead at *Allure*, then came to *Vogue*. Her career now involves more work, less play, but she says, "I've fulfilled a childhood dream."

With Anna Wintour and her other editors, Fino decides which

Novak by Alexander McQueen

accessories to feature in *Vogue.* They base their choices on several factors, beginning with the seasonal trends they observe on the runways of Milan, Paris, and New York—an eighties influence, perhaps, or elongated bags. Later they combine this information with the recent work of favorite designers (often also advertisers) and the needs of the time of year, from warm coats to beach gear.

The result of this editorial collaboration is a fashion theme that inspires a feature story told mostly in photographs: a fable set on the African savanna to highlight safari-inflected styles, say, or a fifties fantasy about Ava Gardner to illustrate ladylike yet smoldering dresses. Should the right bag not be available, *Vogue* might ask a favored designer to create one, which might later go into production. "This is not a shopping-guide magazine," says Fino firmly. "We're creative people who tell a story in our photo shoots, because the reader responds with more satisfaction to that." Great new purses that don't fit into a narrative feature appear in one of *Vogue*'s departments. "If Marc Jacobs tells me the oversize bag is the 'in' thing of the season," says Fino, "I'll incorporate that in a style section that informs the reader about trends."

As an experienced fashion professional, Fino regards the It bag craze as a largely commercial phenomenon. In the not-so-distant past, when clothes were more important than accessories, she says, a woman bought a single luxury purse for a lifetime and perhaps one for each season. Since designers realized how profitable purses can be, however, "a model

doesn't go down the runway without a bag, which you didn't see twenty years ago," says Fino. "The message is that when you're wearing a certain designer's clothes, you carry that designer's bag. And if you can't have a Marc Jacobs, then you want one that looks like a Marc Jacobs, even if it's from the Gap."

Like many tastemakers, Fino regards Jacobs and Miuccia Prada as "the two designers who have really changed the industry, making everyone else into some kind of 'version of.'" Calling Prada "a visionary," she says, "editors see a season ahead, but when we're thinking blue, she's already thinking red." She interprets the old Prada family logo on the new supersize bags as "Miuccia saying 'I need to return to my roots.' Everybody else is still thinking about the It bag, but she has already gone somewhere else. Her genius is that she can detach herself from what's going on culturally and in fashion and be in a world of her own, looking ahead."

As a fashion editor Fino must also see beyond the season to long-range changes, and she too is "a little past the It bag." What will replace it, she thinks, is an expensive, high-quality purse "that's not necessarily one that you'll see everywhere on the street. It will be more about the no-brand bag, about the shape, and less about the designer's hardware screaming out." Such a low-key but distinctive bag might come from Tod's, the Italian company known for its driving shoes and now for classy, versatile purses such as the D. "You won't see it right away," says Fino, "but the purse is moving toward becoming

more of an elite item that works for you in all seasons and with everything you own."

~

OUTSIDE THE CLOISTERS of a few haute magazines such as *Vogue*, tastemakers must pay more attention to practical matters when choosing bags for their readers. At *More*, a sensibly stylish monthly for women over forty, Lois Johnson offers one of her personal criteria for a great purse that would serve any busy woman well. "Bags have become our home away from home," she says. "Before I buy a new one, I dump the old one out on the counter, and if the new one doesn't hold all my stuff, I don't take it."

On the wall behind her desk is a winter layout that represents the kind of fashion information that Johnson offers her readers. Pointing to a supersize white hobo whose Bottega Veneta version she would like to own herself, Johnson says, "I want to present our women with something that looks fresh, like this big winter white bag, and that's different from what they're likely to have already. I'll alert them to the trendy shape, color, and texture, and also offer them options at different prices."

As a fashion arbiter for women who might be sending kids to college, buying a second home, or starting a business, Johnson must balance their desire to be chic with their other goals. One of her twenty-something assistants has a five-thousand-dollar Birkin, but like her readers, Johnson has

other financial priorities, and her black suede Prada's honorable patina bespeaks years of use. For producing well-made purses in good leather that are neither too expensive nor too cheap, she praises Coach: "That company has done a lot to democratize luxury bags—and back before Prada, every model had a Coach bag."

An editor at a mainstream women's magazine can be less concerned with high-priced It bags and logos than her peers at *Vogue*. Because hot styles are so quickly knocked off, Johnson feels that a purse that conveys a woman's timeliness and taste trumps one that merely displays her wealth: "If you have a Balenciaga, Chloé, or Mulberry bag—or one that could pass for one of those—you're saying 'I'm a hip fashion insider.'"

Regarding the language of bags, Johnson says that like praising a stranger's dog, admiring a stranger's purse can create an instant bond: "The bag has become the touchstone for getting a quick take on someone. It's something men will never understand." Recently, when she spent a day helping prepare a young French actress to play a fashion editor in *The Devil Wears Prada*, Johnson was struck anew by the purse's communications potential: "The first thing she said to me was, 'Can I see your bag? I want to look inside to get a feeling about you. It's all about the bag.'" Later, the actress asked what purse Johnson would take to a black-tie dinner: "That she started building her whole character on those two purses is really interesting!"

~

As an editor at large who covers style and design for *Time*, Kate Betts is a different kind of tastemaker from peers at *Vogue* and *Harper's Bazaar*—her former berths—or even at mainstream women's magazines such as *More*. The bags she chooses to show in the newsweekly are seen by millions of readers who span the style spectrum and may be more interested in the fashion business than in design.

When deciding on what to feature in *Time*, Betts looks for a purse with a "very current fashion message" from an influential designer whom others will copy. That way she's delivering news and also forecasting a popular trend—information of interest to a broad range of readers. Offering an example, she says that when Silvia Fendi embraced embellishment with the Spy bag's totemic closure, which Betts calls "that weird dangling thing," the directional designer wasn't just presenting a new purse. She was also signaling that bags in general would become less about utility and more about being "quirky and different." Accordingly, says Betts, "handbags are no longer necessarily about function at all."

When reporting news and forecasting trends, Betts often presents *Time* readers with some consumer-friendly information as well. In one issue, she highlighted the popular slouchy hobo, then showed bags from three companies, including the increasingly hip, reasonably priced Cole-Haan. Along with the criteria of timeliness and good value, Betts likes to fea-

ture accessories designers that, unlike Prada or Chanel, "you wouldn't necessarily think of off the top of your head. Right now I might do one of Ralph Lauren's metallic bags, which are very nice."

To arrive at the right mix of fashion and practicality, Betts draws on her own experience as a stylish but busy American working woman. "I'm not such a fashiony dresser, so I like the statement of a bag," she says. "Even an ugly one can express an interesting point of view." On the other hand, she also has to transport lots of stuff on her rounds from home—and two small children—to office, and would prefer not to lug a tote, too. But, she says, "if you tell designers that you want to be able to carry files or gym clothes, they kind of look down on you, like 'Why would you admit that you do that?'"

When choosing her own bags Betts prioritizes shape and color, avoiding black. One all-time favorite is a classic Hermès Trim in a raisin-plum shade that was an exercise in retail therapy: "I bought it for myself when I was fired from *Harper's Bazaar*, so it has symbolic importance." So does her one-of-a-kind treasure: a simple quilted satin fold-over Chanel clutch, complete with her initials in gold, that Karl Lagerfeld had made especially for her.

∾

EMBODYING THE FLUID boundaries between the worlds of fashion media and design, Marin Hopper, who's now a consultant for Tod's, was previously the fashion director of *Elle*.

Describing the magazine as "very accessories driven," she says, "We had the pages to do everything from little jeweled evening purses to big travel bags—whatever we saw that reflected a certain moment." Eventually Hopper decided she wanted to be involved in making bags, rather than just reporting on them, and switched careers. "I wouldn't call myself a designer, exactly, but more of a creative director."

After Hopper joined Tod's, she drew on her fashion editor's background to help launch the company's younger, sportier Hogan line, whose recent successes include the rich-hippie Fringe shopper. To Hopper much of the popularity of such bags derives from their ability to update a woman's look quickly and easily and to dress up ubiquitous jeans: "With all that denim as the backdrop, colored accessories—even white, which looks better dirty—function like neutrals."

As do many tastemakers, Hopper has fashion in her blood. She's the daughter of actor Dennis Hopper and writer Brooke Hayward. "Like Jackie Kennedy," she says, "my mom had a thing for Gucci and Bottega Veneta. One of those was always on the seat of the car when she took me to school. I have such a bag thing because of that. Totally! When Tom Ford made that Jackie O for Gucci, oh my gosh, I had to have it in every color!" Hopper and her employer hope that mothers who carry high-end Tod's bags will give Hogans to their daughters. After all, she says, "most twenty-five-year-old girls working in a gallery or for a magazine can't afford a thousand-dollar bag. They have to get their mothers involved."

As a Hollywood-based consultant, Hopper closely watches those trendsetting twenty-something fashionistas, because they're "very directional," she says. "When I see a cute girl on the street, the first thing I think is 'What bag is she wearing?'" Sussing out those It girls, whose cutting-edge style forecasts mainstream trends, helps Hopper develop the concepts that inspire Hogan's designs. "Having been a magazine editor, I naturally think in terms of 'What themes are happening next?'"

Fashion themes may seem ephemeral to outsiders, yet they often shape our taste. As some brands are focused on career women, say, or the outdoors or the hip-hop scene, Hopper says that Hogan is "about travel, luxury, and a young lifestyle." Accordingly, its themes have included aviation, motorcycling, and surfing—iconic activities that summon up a certain stylish, adventurous sensibility and help focus an ad campaign. Hogan's designers express a theme's spirit through a bag's hardware, fabric, color, or other elements in a way that suits the brand. Citing a particularly successful example, Hopper says that the safari theme produced Hogan's Scout bag, "which was huge. It was shot a million times with Jennifer Aniston and appeared everywhere from *People* to *Vogue*."

Recently Hopper has been working on Hogan's big theme for fall 2006, which is music, and on the guitar-strap bag it inspired. "We want to be a crossover brand that appeals to someone who does music, film, sports," she says. "Maybe that kind of girl will be wearing a snowboard-inspired boot and the guitar-strap bag."

~

MUCH LIKE TOP fashion editors, Bergdorf Goodman's Roopal Patel is one of the store buyers who's a tastemaker for the stylish elite. Because her choices are watched by mainstream merchants and her customers are often photographed, her influence filters into the popular culture as well. Employed by a very-high-end retailer, Patel has more latitude than most buyers. "We want to offer the epitome of luxury and fashion," she says. "We're able to take chances and test new things."

Even Patel was surprised when Bergdorf's promptly sold a $25,000 limited-edition alligator bag that Gucci had produced as a promotion for an advertising campaign. To tempt particularly lavish customers, the store offers a $110,000 Darby Scott evening clutch that's covered in semiprecious gems.

Patel makes her high-stakes decisions four to five months ahead of the selling season, just as fashion editors do. She, too, bases her choices on visits to designers, media buzz, and the runways. "If you see there's going to be a sixties trend, you know you'll need patent leather bags," she says. "If there's a natural trend, you'll want some woven things." When it comes to identifying the purse of the next moment, adds Patel, "An It bag is clear to everyone."

A tastemaker must forecast, and looking ahead to the accessories of fall 2006 and spring 2007, Patel predicts an eighties influence, the return of the black bag, and the rise

of teal and purple, particularly in patent. Regarding up-and-coming It bags, she singles out the Fendi B, Chloé's Edith, and Marc Jacobs's big tote shapes.

Because she's a fashion arbiter Patel's own bags are newsworthy, and interestingly, she too avoids Its. She prefers what she calls "no-name brands" such as Rafē, and wants one of the small company's new colored patent bags. On the other hand, Patel wouldn't say no to her own personalized white Kelly or a custom-made Goyard, which she calls "the new generation's Hermès."

~

ISAAC MIZRAHI IS a designer, but thanks in part to an irrepressible personality that inclines him to greet perfect strangers with a peppy "Hi, darling!," he's also a tastemaker—not only to the couture class but also to the masses. One major venue is his just-us-girlsy cable show on the Style network, where he might, for example, show Academy Award nominee Keira Knightley and his live audience how to walk in high heels. The other is the nationwide chain of Target stores.

To add some star quality to their merchandise and octane to their ad campaigns, the retail giant hired Mizrahi to produce high-style clothes and accessories at low, low prices. To him, the Target collection is "a way of reaching out, of making good things more accessible. Here and there I can even do a leather bag, a suede bag."

As both a designer and fashion arbiter, part of Mizrahi's

charm is his soft sell. Where the purse is concerned, he says, "You can even carry a shopping bag, which is my favorite. Oh my God! Those Commes des Garçons ones are amazing!" Although he makes purses, he views them as optional—"a luxury on any level. You cannot ignore your hair or your shoes or your bra—those things you must, must, *must* come to terms with. But it's not the nineteen fifties or sixties, when you had to carry a certain bag with your outfit. Your bag can be your totally functional friend or your amusing court jester." (Regarding the latter, Mizrahi says that just the other night, the socialite Anne Bass opened her evening bag and showed him her hand-carved pillbox, shaped like a walnut and covered with diamonds: "Oh! I want one!")

The glamour of contemporary Marie Antoinettes and their accessories notwithstanding, Mizrahi's own taste in bags inclines toward the practical. "For me a great purse is all about function," he says. "That's who I am. Vivienne Westwood would say, 'Glitter, glitter, glitter.' Something that looks really good. But I think that a bag that functions beautifully looks great—better than a fancy one." Observing that Hermès purses are both classic and businesslike, he says, "I don't like things that are very trendy and then gone. Karl Lagerfeld is a master at making accessories that look new but will last."

Target may not be Chanel, but Mizrahi tries to bring a couturier's creativity to his work for the huge chain. "If I can think of a bag that can be worn a different way—across

the body like a messenger bag or like a bracelet—I get very excited!" he says. Recently he's become turned on by big industrial mailbags: "That canvas with the stenciled letters on it, you know? And those grommets and leather trim? Because at least one of my feet is planted in postmodernism, I think you can wear an evening dress and carry a mailbag and look gorgeous."

For the woman who's not quite ready to borrow her postman's sack, Mizrahi generously exercises his tastemaker's power on behalf of another designer. "I just saw a kind of satchel-like Marc Jacobs bag with a forearm strap," he says. "The size looked very directional—bigger than a purse, but smaller than a tote. Harder than a hobo, but softer than a pocketbook. And it was bright red!"

~

WE MAY BRISTLE at the fact that the accessories we buy have in a sense been preselected for us by powerful fashion arbiters. The idea that we can form emotional ties to a favorite everyday object, such as a handbag, can be even more discomfiting.

FIVE

Pursonality

Bags and Behavior

~

Kate Moss with a Prada backpack

THE MOST OBVIOUS reason why we bond with a certain everyday thing, such as a handbag, is that it fulfills a necessary function, such as carrying our stuff. Market research suggests that we especially like "hedonic" action objects that are fun as well as functional. Thus a Bottega Veneta East West shoulder bag or even its stylish knockoff is likely to make our hearts beat faster than a no-frills canvas tote. However, when we are confronted with both options, guilty feelings about hedonism incline us to make the more sensible choice—perhaps one reason why stores don't position It bags near shopping totes.

Like a Mercedes or a Lexus, a $2,600 Bottega is a potent status symbol that affects how we see ourselves and how others see us. In his classic work *The Theory of the Leisure Class*, Thorstein Veblen wrote, "Our apparel is always in evidence and affords an indication of our pecuniary standing to all observers at first glance. . . . Dress, therefore, in order to serve

its purpose effectively should not only be expensive, but it should also make plain to all observers that the wearer is not engaged in any kind of productive labour. . . ." No one could mistake the Bottega bearer for a blue-collar girl. On the other hand, most buyers of luxury bags aren't wealthy older ladies who lunch, but younger career women who are more concerned about making an impression.

By expressing what we like and value, possessions can also be icons of our identities. Since Princess Grace, nothing says "classy lady" like a Kelly. The free spirit who carries the green Hogan Fringe shopper announces that while she can spend twelve hundred dollars on a bag, she has a bit of the hippie about her too. In one of *New York* magazine's "Look Book" fashion portraits, eccentrically but expensively dressed Monique Garofalo, seventeen, makes sure readers know she's an iconoclast who wouldn't be caught dead in a mall. Her purse: a vintage Beatles Yellow Submarine lunch box. Fashion historian Valerie Steele even finds that a woman may express contrasting aspects of herself in evening and sporty bags that are often as different as night and day, with the former regarded as jewel-like art objects and the latter as essential supports.

Using a handbag as a form of self-expression would neither surprise nor dismay psychologist Mihaly Csikszentmihalyi, whose research on our everyday lives and things shows that we—especially women—particularly value "contemplative objects" that have positive associations and represent dimensions of who we are. Indeed, Csikszentmihalyi asserts

that being able to turn a possession into a meaningful symbol is crucial to developing a healthy self.

Some everyday things are so-called transitional objects that, like a small child's "security blanket," stand in for someone or something that's missing in our lives. That gorgeous Bottega bag may ease the pain of a husband's infidelity, a career setback, or an empty nest. To rationalize its cost, a hardworking single mother can tell herself—and others—that she may not have much time or energy for socializing or travel, but at least she can have a great bag.

The recent popularity of the pricey purse is yet another indication that transitional objects may be becoming more important in our increasingly materialistic, highly mobile, socially disconnected society. In an unusually comprehensive study, twenty-one social scientists from UCLA's Center on the Everyday Lives of Families spent four years intensively observing thirty-two socioeconomically diverse Los Angeles households. They found that compared with previous generations, family members follow different packed schedules that limit their time together; indeed, five households failed to gather even once during the entire four years. Perhaps not coincidentally, the subjects' homes were cluttered with possessions in a way their forebears couldn't even have imagined; only two families had enough room in their garages to park a car. Yet each week, as if filling the void created by their hectic, socially fragmented lives, the households bought more stuff. As one researcher puts it, "People just can't stop."

Proust's celebrated madeleine showed that an object can unlock a memory, which helps explain why so many women treasure purses handed down from mothers or aunts. To French psychiatrist Clotaire Rapaille, who advises major companies on what we *really* want from our everyday possessions, these deep emotional associations with objects from the past are "archetypes." Observing that he preserved a neo-Tudor teardown house because it evoked an ancestral castle in Normandy, he says, "We want to live in an archetype, and we want a car and a jacket"—and presumably a handbag—"that are archetypes, too."

All of the main emotional ties that can bind us to a special possession are apparent when peripatetic interior designer Nadia Ghaleb says, "My car, my cell phone, and my big Tod's purse—those are the major tools of my life. I like the fact that my bag is not just beautiful, but useful—my office to go" (functional agent). Of course, her purse is also a celebrated It bag (status symbol). Predictably for a designer, Ghaleb sees her accessories as an important form of self-expression: "My bag and shoes are crucial" (identity icon). She traces her enthusiasm about purses to the Hermès bags given by her late father to her mother (memory enhancer). These same purses, which have been passed down to Ghaleb since the onset of her mother's Alzheimer's disease, support feelings of connection in the face of that all-too-common family tragedy (transitional object).

❧

WE MAY DENY or downplay the relationships we form with our special possessions, but cognitive scientist Donald Norman, a professor at Northwestern University, cofounder of the Nielsen-Norman Group, and author of *Emotional Design*, does not. In fact, in boardrooms and on campuses around the globe, he educates business titans and students alike about the importance of our underremarked affective bonds with our stuff. Offering an illustration, he points out that legions of Americans snapped up Apple's colorful new iMac not because they suddenly needed a new PC but because they fell in love with a cool new machine.

The principles of what Norman calls "emotional design" are equally relevant to fashion companies and consumers who want to understand our shopping behavior. In fact, the luxury bag is a perfect illustration of his assertion that a great design isn't just functional and user-friendly, but also appealing, fun, *pleasurable.* From his perspective, when a woman fondles her beautiful Bottega, what she experiences has little or nothing to do with transporting her keys and wallet. "It's all about the feeling," he says, "about something that's a joy and a delight. The things we like give us pleasure."

Until questioned by a reporter, Norman hadn't spent much time considering handbags per se. Quickly warming to the subject, he says that come to think of it, he himself carries a purse. "It's amazing how many briefcases I go through,"

he says, "and some are expensive!" He recalls with particular fondness a handmade "quasi-outdoorish" model in rugged leather with big buckles: "It was neat, actually." Like this briefcase of yore, he says, his ideal bag would be efficient and sturdy enough for a globe trotting academic, but also distinctive: "I want it to say, 'This is Don Norman, who cares about design *and* practicality.'"

Whether we contemplate a macho briefcase or a dainty minaudière, Norman's theory of emotional design posits that we'll react on three levels: the visceral, based on the bag's physical properties; the behavioral, based on its performance; and the reflective, based on the emotions it evokes. Thus his gearish briefcase gets three stars: viscerally attractive, behaviorally functional, and, because it portrays him as both practical and tasteful, reflectively positive.

Like Norman's briefcase, a great handbag excels in all three dimensions of emotional design. The visceral and behavioral components are obvious. Norman is especially interested in a purse's more sophisticated reflective potential. After all, he says, unlike generic possessions, "your bag expresses your own self to two parties—you and everybody else." Even a plucky businesswoman's unconventional decision to carry a backpack instead of the expected purse is revealing, he says: "Like a guy who wears hiking boots to the office, she's saying, 'This is not the accepted practice, but I'm cocky enough to do it anyway.'" Comparing women who eschew bags to well-off college professors who drive beat-up old Volvos, he says,

" 'Simple living' isn't just simple—it's a statement, too. That's why some people take such care to look like they don't care about fashion."

Announcing a concern—or lack of concern—about status to the public is one obvious reflective message that a handbag can send, but its private signals are often more intriguing. Drawing a parallel to a man's billfold, Norman says that he'll pay more for a fine wallet not just because it holds his money (behavioral) and has a "wonderful, supple, leathery feel" (visceral), but because its high quality also enhances his self-image. For all three reasons, he says, "I really enjoy my wallet every time I use it. Nobody else knows about that experience, not even my wife." Such small private pleasures—the snug click upon closing a Judith Leiber evening bag or the cheer cast on a dreary errand by a hot pink Kate Spade shopper—help explain why Norman's research subjects usually answer "perhaps" when asked if they would pay a lot of money for an item that nobody else would see.

The complexity of our three-part emotional response to purses, briefcases, or wallets explains why individuals in a crowd of shoppers see the same merchandise very differently. Just as our personalities vary, says Norman, so do our characteristic degrees of behavioral, visceral, and reflective involvement with objects. For the more behaviorally minded, a bag is mostly about "Does it hold my phone, money, and diary and let me get to them easily?" More visceral shoppers are mostly concerned with the bag's visual and tactile appeal,

while reflective types zero in on its logo or hipness quotient.

Even in a reflectively inclined shopper, that Be & D bag with the wide studded shoulder strap can evoke complex, perhaps contradictory reactions. Just on the reflective level, says Norman, "a little voice might tell you how good it will make you look and feel, but also say, 'More than a thousand dollars for a handbag? Don't do that!'" Despite this conflict, if the purse's visceral and behavioral elements are positive, "you might rationalize going for it."

Our deep if underappreciated emotional response to a certain object's design helps explain not just a budget-busting splurge on a Bottega, but also why a woman can set out to buy a sensible, workaday, reasonably priced brown purse and come home with a jeweled evening bag or yet another black one. As Norman says, "We're much more driven by our subconscious goals and desires than we know or like to admit to ourselves."

Neither an It bag's price nor a consumer's willingness to pay it surprises Norman. Drawing a male-oriented parallel to luxury cars, he observes that *Consumer Reports*, which traditionally highlighted products that gave the most utility for the least cost, like Toyotas and Volkswagens, now also tests high-end cars such as Mercedeses and Porsches. "Previously the guide wasn't considering the emotional appeal of certain cars—particularly to their readers, who as a group are more educated and well off," he says. "They *do* want to display some status, although they wouldn't admit it."

Evening bag

LONG BEFORE MODERN research on the emotional meaning of every-day things, Sigmund Freud put forward an intriguing theory. Because we can't handle direct confrontation with some of our fears and desires, he posited, our species developed universal symbols for them, which appear in our dreams. He proposed that the purse—in his day, a capacious, satchel-like affair—was a symbol of woman and that placing an object inside it represented sexual intercourse. His association of the handbag and the vagina has colloquial support. The term "pussy" is derived from "purse," after all, and in certain elderly circles, a whispered "your purse is open" politely alerts a seated woman that her knees have drifted too far apart. Over time, however, Freud's theory has been simplistically reduced to "purse equals vagina."

In a column in the *New York Observer*, called "Ladies! Open Up Your Purses," cheeky Simon Doonan discussed what he calls Hysterical Accessory Gathering Syndrome, or HAGS, in supposedly Freudian terms. "Once you accept the hypothesis—as I unquestioningly do—that vaginas and purses are totally

synonymous," he writes, "the world becomes a very interesting place." As an example, he wonders if a young woman toting a Chloé Paddington, which bristles with buckles and a padlock, is "transmitting a message of chastity or bondage?"

Psychoanalyst Rhoda Krawitz, who practices in Manhattan and is also researching and writing about Little Hans, one of Freud's famous cases, allows that a handbag is an "evocative object." After all, a purse has an empty space that can be entered and that can envelop or contain; it reveals its outside while hiding what's inside; it can disguise, seduce, or snap shut in refusal. Nevertheless Krawitz is skeptical about "going too far with the vagina equivalent and buying into broad psychoanalytical generalizations. Women carrying vaginas? What about men and briefcases?"

From Krawitz's sophisticated analytical perspective, a purse can indeed represent a variety of things, from chastity to the *vagina dentata*. However, it can do so only for an individual, not for the entire human race. Indeed, she says, for a particular person, a "perfect accessory" might bring to mind—and represent—a penis rather than a vagina.

As a woman who appreciates beautiful accessories herself, Krawitz sees no problem with buying a bag because it's pretty and suitable. A fashionable purse can be a benign way to display oneself as a figure of substance and style, she says, or even as a sexual object. An excessive concern with clothes and accessories, however, can be rooted in different psychological problems. For example, a little girl who was obsessed over

by a stage-type mother may grow up to find that narcissistic gratification difficult to relinquish, says Krawitz: "The fear that she will not be noticed can lead her to acquire notice-able appurtenances, such as expensive designer bags." Often, however, a preoccupation with fashion comes from a sense that something is wrong with one's body. As Krawitz points out, some women even talk about "feeling different" when wearing a new outfit or bag.

A splurge on an It bag can sometimes be a way of relieving emotional or erotic longings. Using shopping as an antide-pressant or to show off correlates with unhappiness; research shows that insecure people plagued by self-doubt are likelier than others to define success by what a person owns, such as a big house, fancy car, or It bag. "Buying can temporarily distance a person from anxieties about the self," says Krawitz, "particularly the question that one so often hears, 'How can I fill that hollow space inside?'"

On the cultural plane Krawitz regards the excesses of the It bag phenomenon as an example of what Marxists call com-modity fetishism: "The fashion industry leaps back and forth in time—short to long skirts, form-fitted to loose-hanging lines, studs to chandeliers—readily enlisting the gullible." Their ranks include older women who have never resolved their youthful identity issues, and so try to enhance their sense of self with logos. Regarding young fashionistas whose identity is still in flux and who yearn to join "the sorority of the haves," Krawitz suspects that Hermès and Gucci are

"supplements to their own names, which they still find inadequate."

Like many women, Krawitz traces her love of great purses to her mother, who was a fashionable beauty in an era of leather bags for work or sport; suede, grosgrain, or velvet for occasions; patent, canvas, or straw in summer. She particularly recalls a simple little envelope bag that one of her mother's beautiful friends gave her when she herself was ten or eleven. "That such an admired woman would unexpectedly give me something that I yearned for was very special," she says. "It made me feel grown-up."

As did the elegant ladies she recalls, Krawitz regards the purse as a piece of an ensemble, "part of a woman's gestalt or portrait." As a seasoned observer of human behavior, she points out that where matters of style are concerned, exaggeration in either direction can be a sign of trouble: "It's just as pathological to be disheveled as to be obsessively wedded to fashion's dictates."

Where the handbag's Freudian implications are concerned, Judith Waters, a professor of psychology at Fairleigh Dickinson University who studies both addiction and fashion, has a similarly nuanced perspective. "Seeing the purse as a metaphorical vagina is like saying a gun or the Washington Monument are phallic symbols," she says. "It makes for interesting discussions that psychology students love."

In less theoretical research concerning appearance and apparel, Waters found that being attractive and well turned out

has monetary as well as psychological value. "The better you look, the more you're paid for the same credentials," she says. "It's worth money." From this socioeconomic perspective, Waters discerns a connection between the purse's increased importance and what she calls "women's work identity. A hundred years ago women didn't have that. They weren't going off to business. Now you see women with a briefcase, a purse, and a rolling bag for their laptops."

As the image of a career woman striding through an airport with a luxury handbag and a computer-laden wheelie suggests, a woman's accessories can both affect and reflect her professional identity. A hypertrendy embellished bag may work for someone in fashion or advertising who wants to look edgy and up-to-the-minute, for example, but it could create the wrong impression for a banker or a college professor. Waters suspects that many career women like Coach because its bags convey good taste and success without ostentation: "As I tell my graduate students, 'What you wear should not be more important than what you have to say.'"

When discussing the larger cultural implications of the It bag phenomenon, Waters wonders why a significant number of women are "so concerned with possessions that not only cost so much, but also can be so difficult to get that you have to go on a waiting list. What does *that* do for you?" She's also curious about the combination of the big, expensive power bag—a status symbol—and teetering stiletto heels—a sex symbol. Following the terrorist attacks of September 11,

2001, she recalls, she saw a film clip that showed one of the Twin Towers' staircases littered with dysfunctional shoes: "I thought, 'Now women are stockbrokers, lawyers, and doctors, so what is all this *Sex in the City* clothing about?'"

In addressing this intriguing question, Waters speculates that, consciously or not, women are struggling to find a way to look both girlie and professional out of fear. After all, she says, "There are not enough men to go around, and fashion can both attract them and substitute for them." Imagining the appeal of an It bag for an overworked, emotionally starved professional woman, Waters says, "It's a case of good old Freudian deprivation—she's trying to fill up this void inside. That purse tells her, 'Look, you're doing the right thing, because your career has enabled you to get a two-thousand-dollar bag.'"

As a therapist Waters becomes concerned if fashion is the only thing that a patient seems interested in, or if she relies on labels to impress others. "Then I begin to suspect an obsession that's an effort to replace something missing in her life," she says. "I'd try to strategize with her about ways to reintroduce herself back into the world—to get a life." On the other hand, she sees nothing wrong in occasionally splurging on a great bag. "A friend and I have our occasional 'mental health days' at the designer mall. If you have the money and think it's fun, why not enjoy?"

~

HANDBAGS ARE HER business, but British designer Anya Hindmarch often talks about them in a behavioral scientist's terms. "Women like to have their things with them," she says. "The psychology of that is so interesting. I watch my young daughter instinctively hoard little beads and bits and pieces and put them into little drawers and pockets. That's really very appealing for females, but whether it's a nurturing thing, a providing thing . . . I long to do a study of it some day."

Like many women, Hindmarch studies what purses say about their owners. "Your handbag is a statement about yourself that shows your true colors or the club you belong to. A very-well-known or bling brand portrays you in one way. A small brand that you don't see everywhere or something you had made by a little artisan in Paris is more inventive."

Some of the quirky charm that characterizes Hindmarch's work derives from her penchant for imprinting her creations with her own personality. "My bags are totally selfish," she says. "I just make what I want to carry." Some of her favorite little things in life, from bows and sequins to traditional British tassels ("so simple and so worked at the same time"), have become trademarks that turn up repeatedly in her bags. Such seemingly small details greatly contribute to a purse's psychological effects, she says: "A handbag helps you to be a sexy femme fatale, or a sleek, powerful businesswoman, or a hippie chick—to play different roles, really."

If many of her bags are stamped with Hindmarch's personality, she customizes several of her most popular styles for

the women who'll own them. The elegant, simple Bespoke Ebury ($1,750 in calf, $8,750 in crocodile) is made to the buyer's specifications, and even incorporates an inscription in the owner's or donor's own handwriting. "Unlike queuing up on a waiting list for a bag, having one especially made for you is the ultimate luxury," says Hindmarch. "Like those old bespoke Vuitton cases, it's a way of creating history. I wish I had an Ebury that my father had given to my mother, and I hope my daughter will have mine long after I'm gone." In a very different form of personalization, the totes and purses of Hindmarch's Be a Bag collection—initially a charity promotion involving celebrities such as Kate Winslet and Elton John—are emblazoned with their owners' favorite photographs of themselves or loved ones, heroes, or pets.

Acknowledging that her purses are often amusing, Hindmarch says, "I like not taking fashion too seriously. Who needs fashion? No one, so it should be fun." Sometimes the jest is obvious, as in the small, hand-beaded evening purses that mimic packages of Cadbury's Dairy Milk, Jelly Babies, and other English candies. Hindmarch's fun-loving streak finds subtler behavioral expressions, too. "When you go out, you might not know if you'll be staying with your boyfriend or not," she says.

Bespoke Ebury
by Anya Hindmarch

"We have a sweet, totally clean little evening bag—silk satin outside and gold leather inside—that has interior pockets for your knickers, toothbrush, and everything you need for an overnight."

Even though bags are her job, Hindmarch talks less about designing or marketing than about their experiential qualities. Like a fine watch, she says, "a great handbag should be something you can show off and enjoy for years. The craftsmanship, the beautiful leather—there's just something lovely and lasting about that. I just got a new handbag, which arrived in all of its tissue, and when I put my things in the pockets, it was a total thrill."

~

THE RANGE OF women's responses to handbags runs from the thrills described by passionate collectors to the scorn of total abstainers. In between the two extremes is a large group of women engaged in a chronic quest for the perfect bag.

Bag Ladies

Some Women's Stories

~

REGARDING THEIR EMOTIONAL responses to the handbag—
or the car, computer, or other important everyday object—
most people fall somewhere in between the
poles of antipathy and obsession. On a fall
Saturday in 2005 at Manhattan's Triple
Pier Antique Show, however, the pas-
sionate extreme prevails, mostly in the
form of middle-aged women and gay
men drawn to a selection of three thou-
sand bags from the 1930s through the
1970s.

A stroll among the numerous ven-
dors' booths shows that Mark de Leon spe-
cializes in high-end designer
alligator and crocodile purses
from Hermès, Chanel, and

*Sofia Coppola with a
Stam by Marc Jacobs*

Dior, which average about $3,500. Ladybag International of-
fers Italian bags from movies shot at Rome's Cinecittà in the
1950s and 1960s that sell for three hundred to four hundred
dollars. RJG Antiques has an eclectic selection that salesman
Brent Allen describes as "from the fifties, but with lots of
forties appeal." Among the most attractive are rigid Lucite
purses, carried like very chic lunch boxes, that he says "are
about just a lipstick and a few things in a bag, very clean
and crisp, very Doris Day." The Mix Gallery's collection in-
cludes many inexpensive purses made of plastic and fabric,
because owner Chery Lin values form over costly materials.
Nevertheless, she's especially fond of a $1,075 red alligator
handbag with gold poodle clasps that was custom-made for
a dog-loving client by Martin van Schaak, who sold only to
private customers.

Despite their many differences, these vintage bags have
one thing in common: Unlike brand-new merchandise, they
have an emotional resonance that appeals especially to indi-
viduals who don't just buy but *collect*. The motivations for
their fevered hunting and gathering vary. Some seek the vin-
tage item's "contagious magic," which would enhance a bag
owned by a Cinecittà actress, say, or Jackie Kennedy. Other
collectors seek items that, like a Victorian lady's travel satchel
or a fifties Lucite purse, allow them to project deep personal
longings onto another time or place.

The antique show's most impressive array of bags, however,
is not for sale: a selection from Gael Mendelsohn's collection

of unusual purses from the 1930s to the 1960s. One morning a few weeks after the exhibit, she guides a visitor through her home, which is almost literally a fun house. There are zany collections everywhere. Along with purses, Mendelsohn pursues outsider art, folk instruments, costume jewelry, and even nineteenth-century "anniversary tin"; these fanciful watches, top hats, flowers, and other metal ornaments were made for couples celebrating a tenth wedding anniversary—an important milestone back in the days of high mortality, especially from childbirth. Even the powder room is lined with rows of rare Vargas-girlish paint-by-number nudes.

The emotional intensity that collectors bring to the pursuit of the purse pervades Mendelsohn's conversation. She cheerfully admits that her vintage collection, kept in a den on the second floor, is "an obsession. I wake up in the middle of the night and say, 'I can't believe I sold that bag four years ago!' My husband thinks I'm absolutely crazy, but collectors just have to have their things."

One wall of Mendelsohn's den is hung with cheery "figurals," or purses that are shaped like other things. The bright red lobster, black-and-white monkey, and bejeweled female torso, woven from basket straw, were once inexpensive fifties souvenirs from Florida. On the coffee table sit two French poodle figurals: a chic black beaded evening pooch and a woolly one with red rhinestone toenails and a pink velvet leash. Illustrating Mendelsohn's preferences for animals and "anything that's unique," her birdcage purse, made from a

clear plastic box equipped with air holes, perch, feeder, and water bottle, once carried its owner's live parakeet or canary.

Mendelsohn's favorite bag is a rare figural made in the 1940s in France by the designer Anne-Marie: a black suede champagne bucket with a lid adorned with Lucite ice cubes and jaunty wine bottle. It took her several years and three thousand dollars to procure this sought-after purse from a dealer. On the other hand, Mendelsohn picked up two other figural evening bags—a Chanel shaped like a VCR tape and Lulu Guinness's green velvet flowerpot of pink silk roses—on sale in department stores "because nobody else wanted them," she says. "They were too unique and avant-garde. I hear that Madonna now has the flowerpot."

Although Mendelsohn sometimes uses her vintage figurals on special occasions, she's likelier to choose something less fragile from her collection of modern designers' purses. In a downstairs room decorated with an array of carved painted coconut heads, she shows off some favorites, including a big black Issey Miyake tote, two Comme des Garçons cube bags, and a glittery Isabella Fiore illustrated with pugs. Despite such riches, for everyday use Mendelsohn usually carries a roomy, nonpedigreed black leather bag that is, she says, "the most normal part of me."

As to why she's such an obsessive collector, Mendelsohn says simply, "I love to have things, a lot of things. My husband says that when I left the hospital after birth, I had a collection of babies' ID bracelets." As a child she acquired

charms, marbles, and dolls, which she kept on shelves in pristine condition. As she says, "I'm into perfection." Along with the enjoyment of looking at her things, she says, "I like knowing that I have something that's rare, that other people don't have. Even with my dogs"—a collection of four Chinese hairless cresteds—"it has to be unique. I just couldn't have a yellow Lab. I'm sorry, they all look alike!"

Whether it hangs on a woman's arm or wall, Mendelsohn feels that a purse reveals a lot about its owner's personality. "Most people stick to the brown or black," she says. For this unconventional woman ("I don't have a normal mind, I'm sorry!"), however, the best purse is "rare and on the figural, funky side. I would never have a Birkin or a Kelly, unless it was very unusual, like the one Hermès made as a joke with a smiley face on it."

~

IF GAEL MENDELSOHN represents one end of the purse appreciation spectrum, Maj. Elizabeth Robbins, currently stationed at the Pentagon, speaks for the other. Like most military women, she doesn't even carry the plain black shoulder bag or clutch that's an optional part of the army uniform. "I don't like the implication that I can't function without a range of female support products," she says. "I like lipstick and eyeliner, but I keep some at home and some at work. In the field whatever I need will be in my rucksack."

For military women the purse is just an accessory to the

larger issues posed by the army dress code. Like female executives, says Major Robbins, women officers walk a sometimes fine line between "being attractive and being distracting." Although West Point first admitted women in 1976, very few female cadets dared to wear the uniform's "skirt option" until 1989, when Kristin Baker became the academy's first female brigade commander. When she put on a skirt, "it became a thing," says Major Robbins, who graduated from the academy in 1992. Even when she wears the skirt mandated by formal dress blues, however, she simply tucks a credit card and twenty dollars into her panty hose waistband. "I don't want to be tied down," she says. "If you carry a purse, it's harder to shake hands or carry a drink."

Because it's worn by all soldiers regardless of rank or gender, Major Robbins likes the army's everyday work uniform of battle-dress fatigues, similar to those in *M*A*S*H* reruns. When traveling in or out of uniform, she carries the popular unisex helmet bag. Many soldiers even customize these regulation black or olive green nylon totes with name tapes and status-laden alternative logos: patches of past and present units. Major Robbins enjoys carrying her helmet bag because, not unlike a Kate Spade or Marc Jacobs, it's "an understated signal. In an airport, say, other military people know you're a member of the brotherhood of arms and strike up a conversation."

(Outside that fraternity many men refuse even to carry a briefcase, much less a man bag. When possible, some try

to dump their phones, wallets, glasses, and other essentials into their partners' already laden purses. Musing on this impractical male taboo, historian Valerie Steele says that in the eighties, the messenger bag joined the backpack as acceptable "because messengers seem masculine. You can call those bags 'gear' instead of 'fashion,' which is really important. But the fine Italian leather bags are really only carried by wealthy gay men.")

The ranks of women who eschew handbags include some who otherwise dress in the very highest style. ("If a woman rebels against high-heeled shoes," said George Bernard Shaw, "she should take care to do it in a very smart hat.") The late haute couture diva Diana Vreeland, who famously said, "Elegance is refusal," considered the bag extraneous and a distraction from an ensemble's silhouette.

With her perfect black separates, flat heels, unfussy hair, and unmade-up face, Tonne Goodman, a Vreeland protégé who's now *Vogue*'s fashion director, might be mistaken for a very chic nun. Waving toward a ten-year-old black Prada—a roomy, simple, rather battered rectangle with shoulder straps—she says, "personally, purses are not important to me. I work with the designers, and I love what they do. But those bags don't apply to my lifestyle. I just look for a bag that holds all the things I need." Although she's on a first-name basis with every famous couturier on the planet, Goodman singles out the anonymous, function-oriented designers of the Gap for Kids: "Their absolutely super-duper backpacks

and jackets that have pockets and slots for earphones and every single thing are brilliant!"

Like fingernails, says Goodman, a woman's purse conveys how hard she works. A well-used, businesslike classic such as hers sends a different message than does a dainty clutch or an up-to-the-minute It bag. That said, for a fashion-world grande dame, it's more stylish *not* to carry the very latest thing but, say, an old Prada.

Some lovely women who look like nuns *are* nuns. Ani Tenzin Palmo, a Tibetan Buddhist, carries a unisex monastic *jholla*, or shoulder bag, made in maroon, yellow, or gray cloth, that has a zippered pocket inside. In an unintentionally trendy touch, some *jhollas* are embroidered with Buddhist emblems. Much like any other modern woman whose work requires global travel, Ani-la likes a bag that is, like hers, roomy, light, and slung on the shoulder; when not needed, she says, her *jholla* can even be rolled up and put away.

Tenzin Palmo may live in a Himalayan nunnery, but she's not shocked at the very idea of spending twelve hundred dollars for an It bag. "That's simply the usual wasteful vanity that is centuries old," she says. "I've just been reading how much money the often indigent Mozart would squander on a pair of shoes." On the other hand, she's puzzled by the cult of designer logos: "Why would anyone pay a small fortune just to advertise a fashion house? The company should pay people for doing their promotion!"

In an essay called "I Hate My Purse," Nora Ephron ex-

plains that she delights in promoting New York City's Metropolitan Transportation Authority by carrying its serviceable twenty-six-dollar plastic tote, adorned with the image of a yellow-and-blue Metrocard. In contrast to her affection for this timeless bag ("never having been in style, it can never go out of style"), she describes her former purse as a "morass of loose Tic Tacs, solitary Advils, lipsticks without tops, ChapSticks of unknown vintage, little bits of tobacco even though there has been no smoking going on for at least ten years, tampons that have come loose from their wrappers, English coins from a trip to London last October, boarding passes from long-forgotten airplane trips, hotel keys from God-knows-what-hotel, leaky ballpoint pens, pathetic Kleenexes that either have or have not been used but there's no way to be sure one way or another, scratched eyeglasses, an old tea bag, several crumpled personal checks that have come loose from the checkbook and are covered with smudge marks, and an unprotected toothbrush that looks as if it has been used to polish silver."

Not surprisingly, Ephron is appalled by purses that sell for hundreds of dollars, "never mind that top-of-the-line thing called a Birkin bag that costs $10,000, not that it's relevant because you can't even get on the waiting list for one. On the waiting list! For a purse! For a $10,000 purse that will end up full of old Tic Tacs!"

~

IF SAMANTHA RAND carries a tote, its logo is far likelier to read CC or LV than MTA. A public relations consultant and stylist who has worked for fashion companies large and small, Rand is representative of a group of women who might be called purse connoisseurs: not as obsessed as collectors, but more interested than the average woman. In her Manhattan apartment she lays perhaps a dozen favorites on her bed, ranging from a pink-sequined evening sparkler from Fendi to her first Prada—an oblong canvas zippered bag trimmed in purple leather.

Women who love purses love to tell stories about them. This particular Prada elicits Rand's tale of a hot pursuit that illustrates the company's savvy marketing of It bags in the mid-nineties. First, *Women's Wear Daily* reported that Prada had given prototypes of the bag to a few top fashion editors. "That created a frenzy in the industry over who got them and who didn't—a power trip in itself," says Rand. "Of course, the photograph also had every reader jumping up and down to get that bag when it went into production."

As one of them—"I had to have that bag!"—Rand hurried to London's Prada store, which actually had two of the several hundred purses that had finally been produced. "I hesitated, because it was a big chunk of change at the time," she says. "When I went back later, they told me how lucky I was that they still had one. That experience of how a company could create not just the bag, but also the must-have market for it, hit me like a ton of bricks."

From the array of bags on the bed, Rand selects an especially nice black leather Prada with braided shoulder straps and two exterior pockets, which she cradles cozily to her long, lean side. Along with the basics, the roomy bag holds her two tiny Buddhas and a vintage hankie. Declaring the bag "perfect," Rand says that since she bought it two years ago, "it has almost excluded my others."

Her pet Prada was expensive, but Rand believes in spending on good shoes, coat, and bag: "You know that they'll always be appropriate—always, always, always—and make you feel that way, too." For her, an unimpeachably great bag is "like a security blanket, in that it makes me feel put together and confident. When I was younger, I wanted to be more colorful, experimental, trendy. But this Prada represents me in the way I want now—classic chic."

Although she has enough great purses to open a small boutique, Rand is still missing her holy grail. "The Birkin is *the* bag," she says. "There was something visionary about it, because it created a role. That bag epitomizes style, taste, and a certain ladylike quality. I covet the Birkin so badly I can taste it. Someday, I'm going to get one!"

Even among women who love bags, most are content with something that costs considerably less than Hermès. On a crisp fall day, Esther Newberg, a doyenne of New York's literary agents, wears a brown tweed trouser suit that's complemented by her brown suede-and-leather Tod's handbag. She has never gone on a waiting list, Newberg says, "but un-

fortunately, I might see an expensive purse that *for me* is of the moment and buy it. But not because someone else has it. And I won't pay more than my rent!"

Newberg's enthusiasm for great purses goes back to child-hood, when her mother knitted her a little black bag with a pink poodle on it. In the years since, her zeal has increased to the point that if she has an evening engagement, she might bring an additional bag to the office, she says: "That's how obsessed I can be." Day or night, however, "my purse is al-ways part of an ensemble," says Newberg. "It makes me feel *finished.*"

In a profession in which image matters, Newberg puts her bag savvy to good use, especially when sizing up dressed-down younger women. "My generation likes things to match," she says. "Wearing a little of this, a little of that—no, I can't do that. But I can tell by looking at someone's bag if she has made an effort to put herself together. Maybe she's just wearing a little blazer and jeans, but when you see the bag, you know the jacket is Roberto Cavalli and the pants are designer. The bag helps you get to that point sooner." If a good bag can redeem an undistinguished outfit, a bad bag can spoil even a perfect one. Remarking on a famous friend's puzzling proclivity for promotional canvas totes, Newberg says, "No matter what else she has on, she looks like a bag lady, because she's carrying something that says 'PBS' or 'Save the Whales!'"

Newberg's bag stories include the tale of a stylish faux

leopard purse that was a gift from a man. Although she loved the bag, she returned it to the store and gave the credit to a relative, "because he was a creep—but a creep with good taste." Her favorite story, however, concerns a lunch date with a woman who had just bought a beautiful black fifteen-hundred-dollar Tod's purse. "I put down the same bag beside hers and told her I liked mine better," says Newberg. "She said, 'How could you? They're identical.' I said that I preferred mine because it cost thirty dollars." With a smile at the brown "Tod's" purse on her desk, she says, "And so did that one!"

~

NEITHER LOVERS NOR haters of purses, many if not most women maintain that they just want a nice-looking, reasonably priced bag that holds all their stuff and goes with their clothes—and then add that it's too bad such a simple thing doesn't exist. Some bring more perseverance and industry to the quest than others, however. Over the past thirty years, Ann Richards, the former Democratic governor of Texas, has refined the design of her ideal "Governor's Bag," which she has made for her in Italy.

"A purse for a woman is like a toolbox for a carpenter," says Governor Richards. "What sent me on the search was the fact that most women can't find their things in their bags. I lead an extraordinarily busy life, and outside my house, all the things that I need are in my handbag." Aside from a

few special items, such as her stash of Equal, a nail file, and a silver boot filled with toothpicks, she says, "I'm not talking flotsam, but serious stuff, like my schedule, phone, and BlackBerry!"

When she set out to design the perfect purse, Governor Richards had a long list of criteria. The bag had to be lightweight, reasonably attractive, durable enough to last a few years, pleasant to touch, appropriate from morning till midnight, and equipped with a comfortable shoulder strap. Speaking of a high-end competitor, she says, "Bottega Veneta has one that I really like, but a man must have designed it, because it won't go on your shoulder."

Above all, of course, the governor's perfect purse had to provide easy access to her stuff. After much trial and error, her ultimate bag is a hobo whose inside-out design stores her most important items in flat exterior compartments. At one end is an open pocket for glasses or a cell phone; the other shows the zipper of an inside pocket for keys. One of the bag's long sides is a flat pocket with a magnet closure for stashing the day's agenda, from a travel schedule to a grocery list; the other is a catchall pocket for miscellaneous items, like her penknife. Finally there's a snap-on card holder for an electronic key to gates and doors.

Governor's bag
by Ann Richards

The bag's interior is designed for high functioning, too. Visibility is boosted by a light-colored Ultrasuede lining; hot pink works well. There are more pockets for communications devices near the top, where they're easy to grab. Thanks to small metal feet, the purse can be set on the floor without getting dirty; it's also structured so that it won't tip over and spill its contents.

One day, as a kind of public service to career women, the governor hopes to sell her bag on TV, for less than two hundred dollars. Previewing a marketing strategy that will confound Karl Lagerfeld and Miuccia Prada, she emphasizes that her bag is "not for fashion purposes, but to carry certain things. If you're not busy, you don't want this purse."

Protestations of sheer pragmatism notwithstanding, the governor is clearly pleased with her bag on a girlie level, too. "I think the purse looks good," she says—good enough to have in many different colors. Her current favorite is "a sort of bronze, which doesn't clash no matter what I'm wearing."

A glance at another woman's purse tells the governor whether its carrier is a potential customer or not. "A little bag, or one with sharp edges or a teeny strap, just says, 'There's nothing in here except my lipstick.'" And those bags that have the little chains and things on them, so when you go to an important meeting and put it down on the table, it goes *clank*? Those purses say, 'This woman hasn't thought ahead.'" However, experience suggests that most women are customers waiting to happen. "If I tell a table full of women about

my quest, every one of them will get up and show me what's wrong with her purse." says the governor. "I want women to have a shot at carrying something that makes sense. My bag is just something that they need—that's all."

Two friends are exceptions: Gossip columnist Liz Smith doesn't carry a purse. "When she goes out to dinner, she puts a lipstick in her jacket pocket," says the governor. "If she needs a mirror to put it on with, she uses the blade of the knife on the table." The other acquaintance needn't carry anything at all. Nevertheless, at a formal dinner during a visit to Texas, Queen Elizabeth arrived with a lovely evening bag. What's more, after taking her seat, she reached into her purse and pulled out a little piece of twisted S-shaped gold. Then, she hooked one end on the table's edge and hung her purse from the other. "It was charming!" says the governor. "The queen—or someone—has given her bags some thought!"

Before her royal visitor arrived, Governor Richards asked her friends what they most wanted to know about Her Majesty. "The universal answer was, 'What does she carry in that purse?'" she says. "I didn't actually ask the queen, but I saw—a lacy linen hankie and a lipstick!"

❧

No one in her right mind could say that a deeper appreciation of handbags changed her life. On the other hand, after spending some time on the subject, I find that some of the little things in my life have indeed changed, and research

on well-being increasingly shows that little things can mean a lot.

First, I have some nice new bags, which brighten quotidian events like running errands and are fun to admire and fondle. Thanks to a certain new savoir faire regarding accessories, I no longer carry day purses on evenings out or match my bag to my shoes. Dirty white and pink are my new brown and black.

The people in my life have responded to my new interest in bags. Some friends have given me funny looks ("You're writing about *what*?"). Others have shared crazy bag stories and taken me on outrageously enjoyable purse crawls. I even caught my husband lecturing puzzled dinner guests about the attributes of my new evening bag.

On a more serious note, writing this book has helped me gain on my initial goal of learning more about our poorly understood emotional ties to special everyday things. I'm fascinated by the parallels between the purse's growing significance and women's expanded lives. I admire the way that a beautiful bag upholds the value of creative design and fine craftsmanship in a world of increasingly homogenous mass-produced goods. Observing how accessories makers combine talent, timing, branding, celebrity, and promotion to come up with an It bag gave me more insight into modern marketing than any dull textbook could.

Most important, listening to average women and tastemakers alike talk about their own bags helped me see how

a simple possession—one of life's little things—can become a partner in a silent but rewarding relationship. Whether it's transporting my stuff, expressing my taste, preserving a memory, or cheering up a bad day, my bag now seems, as William James suggested, not just a thing, but also a small part of who I am.

Acknowledgments

~

FOR SHARING THEIR knowledge of fashion in general and handbags in particular, I'd like to thank Kate Betts, Joanna Coles, Silvia Fendi, Filipa Fino, Nadia Ghaleb, Tonne Goodman, Wendy Goodman, Anya Hindmarch, Marin Hopper, Lois Johnson, Reed Krakoff, Rhoda Krawitz, Ellen Goldstein-Lynch, Helen Mariën, Gael Mendelsohn, Isaac Mizrahi, Donald Norman, Roopal Patel, Paige Pedersen, Candy Pratts Price, Samantha Rand, Ann Richards, Elizabeth Robbins, Michael Segell, Kate Spade, and Judith Waters.

For their enthusiasm as well as their professional skills, I also thank Gail Winston, my editor; Kristine Dahl, my agent; Alanna Cavanagh, the book's illustrator; and Jonathan Burnham, Anna Weissman, and the HarperCollins team.

Notes

~

xiii. Their testimonies suggest . . . William James, *The Principles of Psychology* (New York: Henry Holt, 1980).

8. She may favor the horn-rimmed glasses . . . Valerie Steele, *Handbags: Lexicon of Style* (New York: Rizzoli, 2000).

24. In a rare interview, while discussing the excitement . . . Susannah Frankel, "The Feeling Is Miuccia," *The Independent* (UK), Feb. 21, 2004.

25. As she explained to British *Vogue*, "I was born into accessories . . ." Colin McDowell, "Miuccia Prada Live," *Vogue* (UK), Nov. 24, 2005.

31. One of their staunchest mentors . . . Ellen Goldstein-Lynch, Sarah Mullins, Nicole Malone, *Making Handbags: Retro, Chic, Luxurious* (Bloomington, IN: Quarry, 2002).

65. Market research suggests that we especially like "hedonic" action objects . . . Erica Okada, "Justification Effects on Consumer Choice of Hedonic and Utilitarian Goods," *Journal of Marketing Research*, Feb. 2005.

65. In his classic work . . . Thorstein Veblen, *The Theory of the Leisure Class* (New York: Penguin Classics, 1994).

66. Using a handbag as a form of self-expression . . . Mihaly Csikszentmihalyi, *The Meaning of Things* (New York: Cambridge University Press, 1981).

67. In an unusually comprehensive study, twenty-one social scientists . . . Joseph Verrengia, "American Families' Plight: Lives Structured to a Fault," *Seattle Times*, Mar. 20, 2005.

68. To French psychiatrist Clotaire Rapaille . . . Jane Gross, "A Dream Life Freud Would Have Envied," *New York Times*, Nov. 8, 2004.

69. We may deny or downplay the relationships we form . . . Donald Norman, *Emotional Design: Why We Love (or Hate) Everyday Things* (New York: Basic Books, 2005).

73. Because we can't handle . . . Sigmund Freud, *Beginner's Guide to Dream Analysis* (Champaign, IL: Standard Publications, 2003).

73. In a column in the *New York Observer* . . . Simon Doonan, "Ladies! Open Up Your Purses," *New York Observer*, Oct. 31, 2005.

75. Using shopping as an antidepressant or to show off . . . Robert Arkin and LinChiat Chang, "Chronic Self-Doubters Tend to Be More Materialistic," *Psychology & Marketing*, Aug. 2002.

84. Despite their many differences, these vintage bags . . . Russell Belk, "Possessions and the Extended Self," *Journal of Consumer Research*, Sept. 1988; *Collecting in a Consumer Society* (New York: Routledge, 1995).

90. In an essay called . . . Nora Ephron, "I Hate My Purse," *Harper's Bazaar*, Sept. 2002.